PAINT YOUR THOUGHTS

Colourplay of ideas into original drawings
unto your sketchbook

Mo Leyva

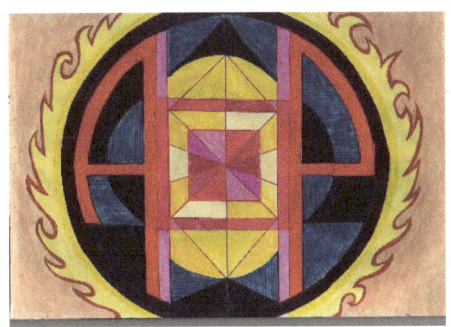

Contents

Preface — 3

Foreword — 4

Introduction — 5

Medium of Expression — 7

Individual Images (early works) — 9

Individual Images (part two) — 17

Individual Images (gallery) — 24

Group Series — 44

 E.B's Dream — 45
 Vicious Triangle — 48
 Rainbow — 51
 Pious Squares — 55
 Lotus — 59
 In Blue — 62
 Flowers of Joy — 67

Epilogue — 71

Acknowledgements — 72

Preface

Welcome to the *Paint Your Thoughts...Colourplay of ideas into original drawings unto your sketchbook*. This e-booklet is a collection of colourful drawings specially chosen from the handy sketchbooks and the corresponding thoughts, captivating ideas, or some trivial story or stories about the images. It is designed for the common readers who appreciate individual talent and original artistic endeavours which are totally free from the so-called "commercial bureaucracy". It is also dedicated to those institutional patrons who may wish to get a "glimpse" of thoughts inside an artist's head about a particular drawing.

What really is the reason that makes this e-booklet different from the usual?
I think first and foremost, it all comes to the basic fact that this is one of the most straight forward expression in words and pictures what message the artist is trying to convey. Second, originality is the operative over-all keyword for all the images. Hence, the images are purely original from the artist's point of views or thoughts. Third, the variety of topics or themes are described in a comprehensive manner, giving the reader a vivid image of the story/stories behind each image.

And most of all, what makes this e-booklet unique is the clever interpretation of what the author cum artist has done to fully express the "thoughts" through the texts and drawings, despite the fact that he is not a professional artist or even a part-time painter. And the other fact that he is a non-native English speaker. (It is quite obvious on the "bookishness", too many adjectives and superlatives being used; in addition to the syntax and grammar that are somewhat "un-colloquial"!)

One last note is hoping the pictures and captions you find in this booklet will give each one of you, your family members and friends' enjoyment, advice and more importantly full delight.
-----Mo Leyva

Foreword

It has been quite some time now since I have read and given a commentary as a foreword to a book of this genre.
Paint Your Thoughts...Colourplay of ideas into original drawings unto your sketchbook is a forward thinking booklet. At first glance on the images and scanned the related captions, I boldly say this statement: As a general conceptual entertainment advice book, this one is good. The simplicity of the layout drawings, how they are grouped and classified and the honesty behind the captions of each drawing gives this mini book an edge.

Though I find the syntax of the language a bit detailed in a "lengthy manner" in some parts here and there, we may forgive the author's unfamiliarity of the English language. In addition to the fact that his limited words he has used were a product of long years hearing different kinds of "Englishness" coming from different parts of the world...say how the European, Canadian, Australian, Irish, Scottish, Mid-eastern, Asian or even Sub-continental English sounds...not to forget that he has been educated in an American syllabus. But in all of these, he remained true to just simply express his thoughts.

From the table of Contents up to the Acknowledgements chapter, the reader will find the sincerity of the author with a pure heart to express what is on his mind. Despite the fact that the individual images has a valuable story of its own, I find some of them quite pretty interesting for both the modern generation of readers and the classic typical ones. But what has given me a sense of fulfilment in reading and appreciating the images are on the chapter Group Series. The diversity, connectivity and relevance for each picture for a particular serial are impressive impacts. Although, some phrases and comments were not really relevant to the generation XYZ youth, but rather appealing to those " age of the Aquarius or early seventies" up to the techno-Pop eighties!
-----Greta Smith-Narineda

1	Introduction

Colourplay Ideology

It has always been my long time passion to draw, sketch or just simply scribble anything that comes up to my mind. Or maybe, this feeling of just doodling or playing on colours started when I graduated in my upper kindergarten class; my uncle gave me as a gift a full set of crayons.

From then on, I would always try to scribble or draw anything that flashes as an idea to me. Sometimes, I may be busy, but the notion still there, somewhere at the corner of my young mind, so I did try to sketch the shapes or outlines in order not to forget whatever comes up.

Obviously, what I am trying to point out is that, it is really easy to paint the ideas from the back our minds, whether it is in black and white, full assorted colours, monochromatic shades or a combination of sorts. Basic steps are simple to follow, in fact, once you have a lingering picture you want to draw or paint; you either do it instantly as you like or you can start on any temporary medium and continue later.

You may think that "colourplay ideology" is but a play on words, coined or termed in this manner to emphasize that all the ideas, emotions and even symbolism can be part of this play of colours. But the plain truth is by simply expressing what you feel like drawing or sketching; whatever comes up, as long as you convey what are your thoughts and feelings. Though we are not trying to be like one of those exponents of the art of expressionism in literal sense. The whole idea is to draw whatever you think and feel.

Freedom Painter

You can be what you want to be while painting; whether you feel like an artisan, an artist or whatever ideology you have and feel

like expressing it. Of course, a real artist tend to be more of a carefree spirit, they are always free in thoughts and direction. They are more at home in expressing things, feelings and abstract ideas. Unlike an artisan, wherein he or she can be defined as skilled manual worker or craftsman/woman. Although these people are bounded or limited by necessity to earn with their artful talent, they are mostly with a full inclination or closer relativity to art itself than the average person.

Now, I imagine a childhood acquaintance of mine who was really very fond of having pet pigeons. I know for sure, that he was into this sport of racing them during his teens. Then when he started a family of his own, he further went into a lot of bird watching. Met him recently and ask about his hobbies, he curtly replied "Oh, they are now in my sketch book, I plainly painted them now!"

And no doubt, how I wonder why a neighbour, another child playmate longed to be like his uncle (a helicopter pilot) when we used to catch dragonflies in the fields and at one time he said he wished to be a pilot when we were flying kites then. Meaning whatever we may dreaming of drawing, from the back of our minds, it could be an extension of our inner self to express. I was not surprised to hear about him took up an aeronautic engineering to design airplanes.

Bootstrap Bottom Line

One of the circumstances that usually pester man is being bored...despite the many things you want to do but not in a mood to do it. A perpetual procrastinator almost bored to death. Only solution is to get down to it. You have to balance time and decide which time you can utilize for this action, or the next.

Aside from expressing your thoughts and feelings by painting, at the end of your session you will come to realize it within yourself. A happy feeling of contentment, a subtle pleasure only you can feel it. So the bottom line is that, such happiness you get after escaping from a prison-like boredom or bewildering activity.

2	**Medium of expression**

Tools of the Trade

Though "Tools of the trade" sound a little bit commercialized or business-like, I have it titled so we really mean to be specific on tools, equipment, gadget or any other paraphernalia. And you may think that it is just a simple drawing or sketches on a piece of paper, why bother to be specific; especially when you take it only as a hobby. Well, it is a good question...I must admit, I thought about it in the same way as you do, but the real truth is that, deep in our heart we always do care for our "brainchild", therefore to make it beautiful or at least good looking, then tools must be good as well.

You do not want your work to come out as mediocre, for example by trying to use a second rate pencil, crayon or paper. I am not stating you have to buy an expensive drawing kit or raw materials, my point is that; a better quality at a reasonable price will do, instead of spoiling your work in the middle of your session. Especially, when you are already in the momentum of your work then suddenly you broke a pencil tip or you found out one of the colour paste has dried out.

Raw Materials

The subtitle of this e-booklet is "Colourplay of ideas into original drawing unto your sketchbook". Yes, I reiterate 'unto your sketchbook', but of course it does not end there. I mean you can draw, sketch or doodle on anything you wish, as stated on my introduction--- the real point is to express yourself...your ideas and feelings. You may start with the "humble" scratch paper or writing pad, then gradually to a sketch book or to a fancy personal drawing paper.

I remember the days, when I was still growing up and felt the

urge to draw. It is not a matter of feeling like mused, but a feeling of "inspired" in a sense. Unfortunately, the availability of materials is scarce; but I have manage to drew or sketched on a piece of cardboard, corrugated carton and even at the back of an old poster calendar! So you congratulate yourself, feel grateful enough to be happy and lucky to be in a time when tool kits and raw materials are accessible. You don't have to scratch the walls like a caveman at Altamira caves!

Somebody I know used to draw on satin fabric, linen and cotton materials. And there was this one foreign lady I met at a trade fair who used to draw beautiful design of butterflies and flowers on silk headscarves. They were really fast selling items, even to youngsters looking around for some knick-knack items. And since I was in a non-industrial trade fair, a lot items are design-drawings related, such as coffee mugs with plain sketches, plates with intricate edge design to portrait artists doing caricature or artisan cutting paper silhouette.

So what I am trying to say in short is that you may draw on any material you like, you are free to choose whichever is convenient to you. Or if you wish to combine one, two or three at same time, help yourself. For example, if you are more "inspired" to paint either in plastic sheets, metal, rubber things or wooden boards, instead of the very plain paper or sketch book, the most important step is START with it!

| 3 | **Individual Images** |

| **early works** |

Solo Package

When I was starting to write the draft of this e-booklet (in basic HTML), I was already thinking of mixing both the individual images and the group series in one succession. But then I noticed it won't help in enhancing the impact its presentation. I changed the idea immediately after I wrote table of contents, decided to group individual images first before the series later.

These individual images are painted with various themes different from each image. Apart from being painted months or years apart. Some are ideas or images drawn from memory of an older paintings. Others, I called "colourplay images" as I simply played on colours while painting the images I thought and felt about. Like a solo package with all the trimmings and variety of interests inside.

Wallflowers

Wallflowers is not actually the very first image I drew, though in the catalogue serial numbering, I chose it to be the first. And has chosen as the very first image on this e-booklet. Why? Is it because I could relate a couple or three main reasons: I regarded it as a self-challenge in trying to mix different colouring pencils as a medium? Or partly my semi-wild imagination of on Van Gogh's

wilted sunflowers!

In my thoughts, before painting these flowers on those pots, my idea of flower offering is like a symbol of good things to come, good intentions; not to mention love itself. Like in a normal courtship, or a gesture of respect or good wishes. In brief, it is best to start with something good whether as an emblem or a simple representation of best offering.

I painted the flowers mostly in conventional feminine colours of red, pink, fuchsia colours except three of them which are done in indigo blue. This, in part is when I thought about blue tulips, as well as imagining flowers in bluish colours with the exception of pondering the lucid bluebells.

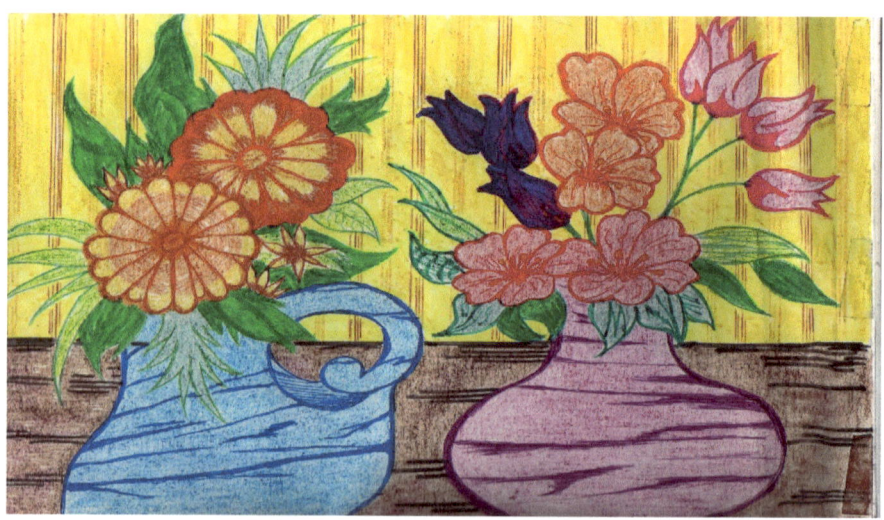

Polychrome Profile

Silhouette images always fascinates me, having first seen black and white paper silhouette images made by one entrepreneur during grade school years. And not to forget, just recently when I met a western woman during summer sales; who cut a silhouette of mine in black paper. To my surprise, when I was about to pay her, she declined to accept the money. Adding it is her way of gratitude to me in letting her practice her simple hobby.

Call it a bit a selfish or egoistic, having my own silhouette but

trying to do it my own way has given satisfaction in expressing my thoughts accordingly. Though not in contrasting black and white but in different colours and shapes to emphasize man's complexities. And in contrast his environment in pencil grey to point out that though living in a modern age surroundings, sometimes life can be lonely and colourless.

Nevertheless, as clearly titled, polychrome profile...many colours of different shades, with an outlook of good things to come. Or in an optimistic way, always hopeful as can be, despite life's ups and down and dull grey coloured treatments.

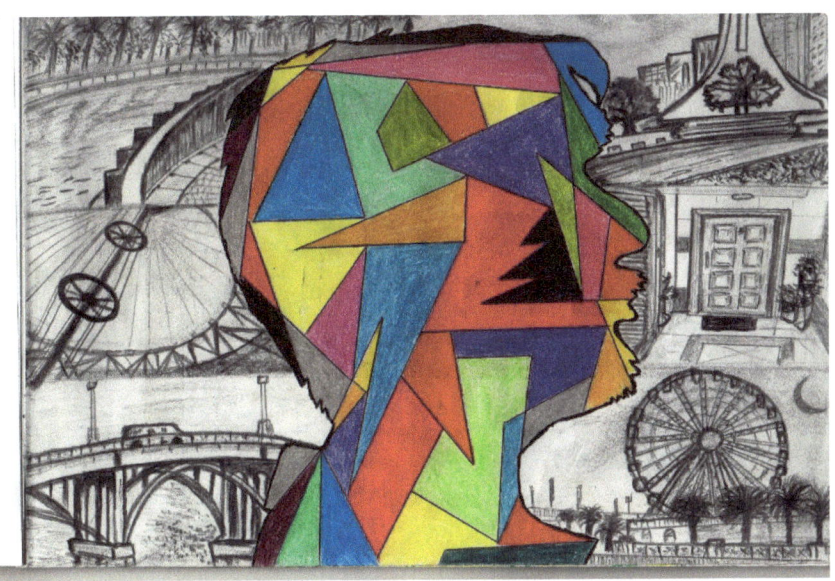

Screen Wired

Despite the many wonderful things that we all have in our surroundings, some examples---hilly terrain, desert landscapes and waterfalls; Man is always bored, always dazzled by new things and (though this may sound like an over-used cliché) man is not always fully satisfied and never end to look for greener pastures.

This image is more of satirical view of man's insatiable desire for new things. Especially when it comes to modern technology, though his brains are wired in so many different gadgets. Try imagining a person inside a theatre; wired to a television set, iPod and laptop computer while his mind dancing to the music of his business affairs!

In fairness to those IT people, technical supporters, computer experts and neophytes---this is where we can get vast information as in self-study, or by simply surfing the internet. One more aspect is communication, which is really vital to living itself. Nobody living in this modern world would deny that he or she can live without ever connecting to the screen...big or small.

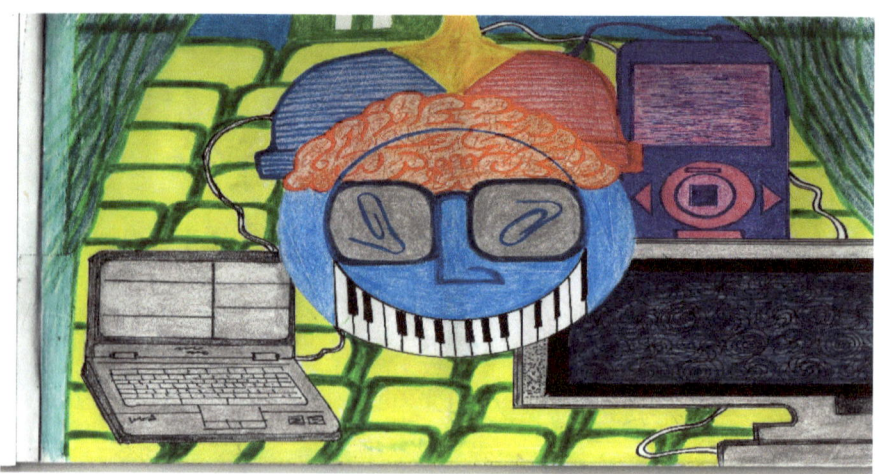

Brave New World

An earlier work which I have done firstly as a simple logo has evolved into a full size A4 painting. The white number one clearly symbolizes the singularity of our home planet. There is no other planet so far known to have supported human being except our very own Earth.

While numerous stars, erupting asterisks and dots are

apparently representing the universe, we cannot hide the fact that our nearest star which is the sun, is ever present with its ever engulfing flames. Another thought, about these flames is the day called "judgement day", a rain of fire or the catastrophic doomsday, or even a wildly imaginative galactic war!

Though it is fairly easy to understand, that the green patch represents earth's mass of land as continents and aquamarine blue colour as the vast wide ocean surrounding it, the rainbow colour diagonal shapes in vertical manner is just a sign of slightest hope of things to come despite the grim reality for this brave new world.

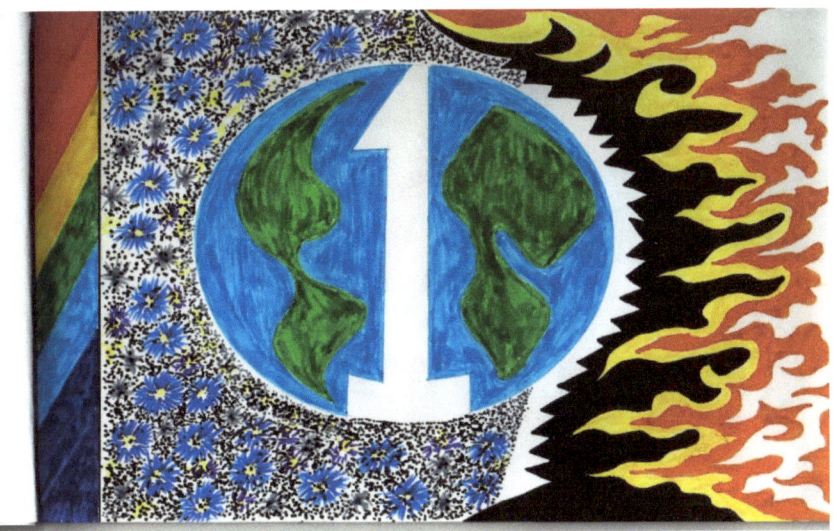

Gazing @ Monitor

An updated copy of medium size poster I have done long time ago in Saudi Arabia. I remember the exact drawing upon seeing an old photograph. Though this time, I have updated it in such a way the currencies were added on the upper right side connects a relation of going abroad simply to earn money.

Homesickness is always a part of life when living abroad, always dreaming of home country and hanging on to live and

sacrifice for loved ones left behind temporarily. It is obvious, our flag carrier's one time logo is ever present in mind, a longing for home in a way while working.

Red and black background was intentionally painted very plain. Black as fear and worry that troubled mind like a shadow. Sometimes like a creeping nightmare on lonely nights.

Red which is almost same size and shape as the colour black gives a sign of relief and hope that, this is it! The rosy future! Keeping your hopes, right focus alive and well for the next years to come.

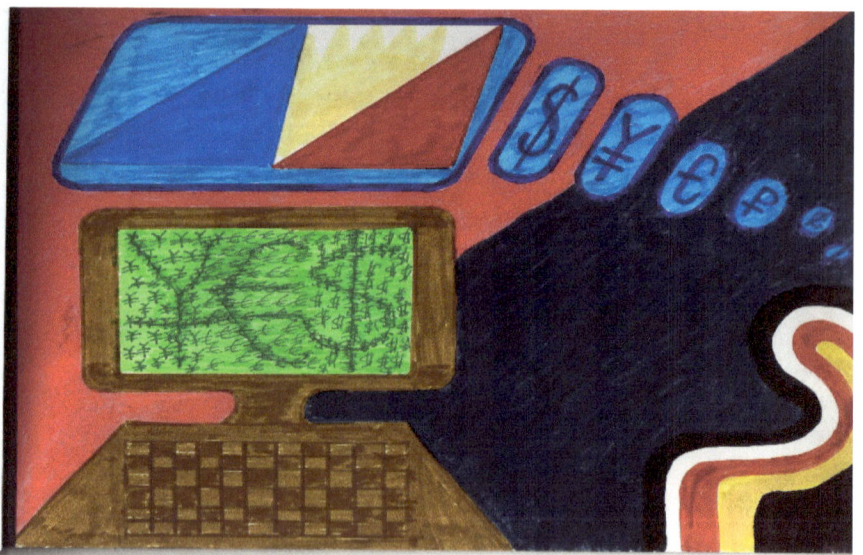

Ating Daigdig

Like the earlier work "Brave New World" at a glance but I have increased the size and modified the presentation of the continents to represent different countries. At the same time another playful thought of having a part on the global issues concerning environment conservation. The reason why the ever present colour green is chosen, is to symbolize "green" topics and

cooperation among nations.

Literally, the words "Ating Daigdig" mean Our World in Filipino, my native language. It is also a way of representing our local collective effort to conserve nature, whether big or small. Incidentally, I first got the idea of drawing this image, while contemplating on the phrase 'ating daigdig, mahaling tigib' as a humble contribution in expressing my care for the world we live in.

Though, the number one image is coloured in the same colour as the background--- aquamarine blue, it represents the unity of various countries, organizations and philanthropic individuals. Their share of help in time, talent, ideas and financial means are not taken in vain. And last but not least, in shade of blue, they are not forgotten in memory. They are like unsung heroes of our time, not wanting fame or glory but only a truthful aid to conserve nature.

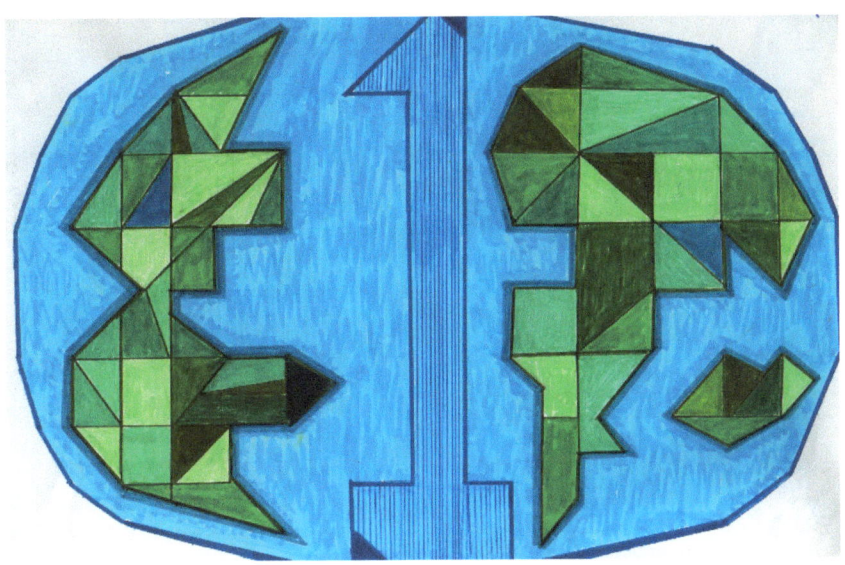

Bicol Express

Bicol Express, is an exalted remembrance of my father's roots. A province called Bicol, geographically a land strip (including the nearby islands) at the southeast of Luzon. As a child,

I already knew three among the many famous things about this place: The volcanic mountain of Mayon, coconut milk and the hot spicy chili.

Hoping the pointed lettering of the word 'Bicol' will match the grey coloured smoke like on the letter 'c' and roof like figure Mayon volcano with the brown-coloured Casagwa ruins. These images are the ones I always remember whenever I see them on history books and local tourist information papers during my grade school years in Manila.

The single chili pictured, just below the mountain like figure is kept centrally to represent my father's native people, who most of them are fond of spicing their culinary delights with chillies and coconut milk. Therefore, I myself also likes to eat food cooked in 'gata' (coconut milk) whether as a delicacy, desserts or sea food delight. Plus the region's famous original viand called "Bicol Express" not to forget the related joke about it but that is another story!

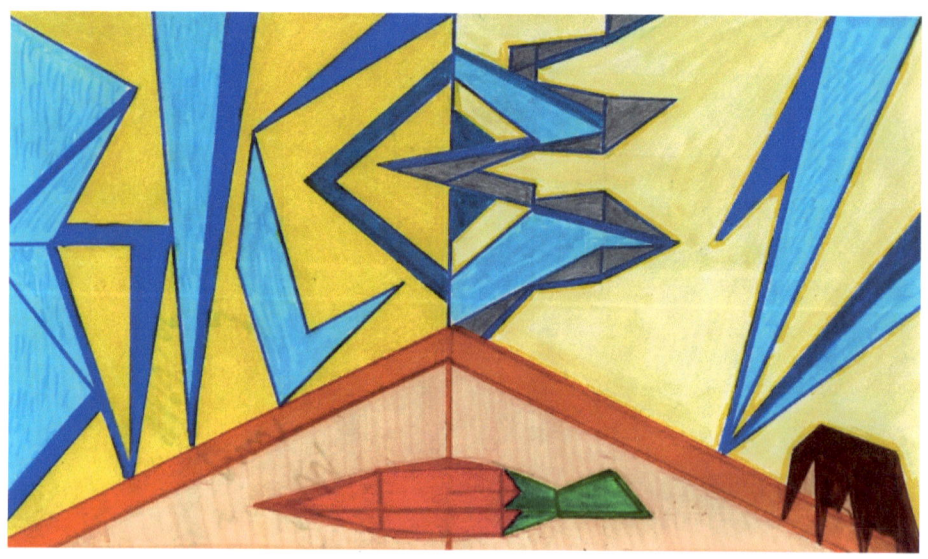

| 3 | **Individual Images** |

part two

Tropical Star

Born and raised up in a tropical country, I am lucky to have seen some of the country side which includes---the lush greeneries of the hills, mountains, lakes and its numerous sandy beaches. (Imagine an archipelago, comprising of seven thousand and one hundred islands!) Surely a long stretch of beaches all around. The long rows of coconut trees, palm trees, and even the ones called 'anahaw' are abundant.

Another iconic image I am very fond of just looking at are the Christmas lanterns during the season's festivities. With all the different designs, ranging from traditional five-pointed stars to multi-pointed ones. At night time, I can say not the least are the countless stars up above, most clearly seen in the country side or suburbs away from the dazzling neon city lights. Sometimes we just play a child's game of counting them until we got tired looking for the brightest ones!

One of the main objective in painting this image of the star within the star itself, is to express the thought of celebrities being discovered then being outshined, fades away then another one comes up and the cycle repeat itself over again. Just like a small shining star then comes another star outshining the first one, and a bigger one outshining the previous with more light for everyone.

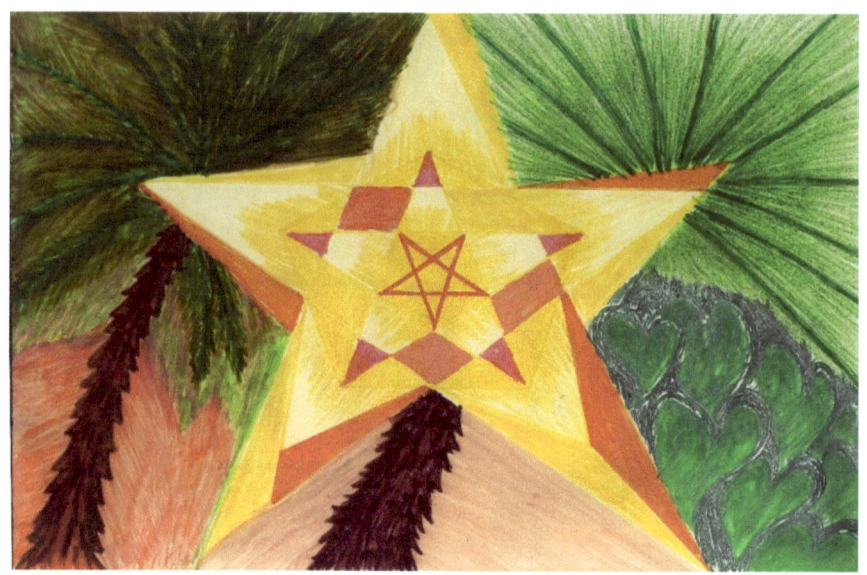

Candle Light Under

 Candle Light Under, has a mellow-dramatic story behind before I was able to compose my thought to put it in drawing. And it has been years, not to exaggerate but it is true, could be decades. Anyhow, I remember a childhood friend of mine who has mentioned these words---"Why are you hiding the light under the wooden cot?" Though I do not recall replying to his query, or even remember how we got into that question. But as far I know it is something to do with one's talent, so to speak.

 The mountain-like figure holding the candle itself signifies the capacity of having multitude of talents, and the floating wooden cot is something to do with the power of knowledge. The power to move things, people and to mobilize or change the situation. The light symbolizes knowledge and guidance; knowledge when used properly will benefit a lot of people, the humanity. Guidance--- particularly when lost in life, emotionally or spiritually.

 I do remember this is the initial time, I found out I feel at ease

in drawing these series of lines in slanted ways utilizing a scale or a straight linear pattern. As I design these lines, I thought of these not only as rays of light emitted from a single candle but the help and guidance reaching out the receiver from farthest places.

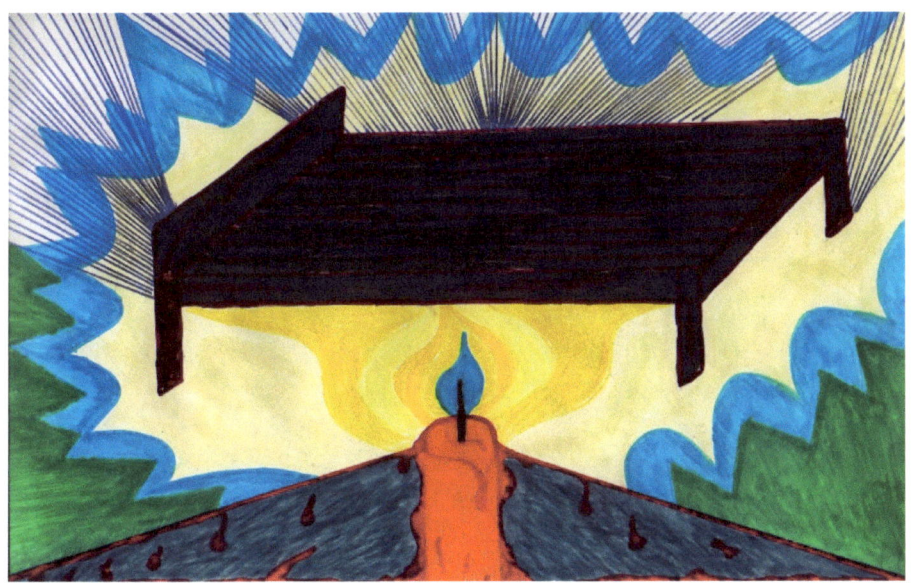

Ginger Brew

Kidlat Salabat *is one of the fictitious character I have created in one of my earlier writings. Literally it means 'Lightning Ginger Brew' or 'Ginger Brew Lightning' whatever it is called I used it comically or satirically. But I have paid tribute to the character partially in this drawing as there is really a pensive reason behind it. Not only the wishful thinking character of the subject itself.*

When I was about to start sketching the outline of this drawing, I thought of my mother's ginger brew. The way she cuts the ginger into little pieces and boiled it with brown sugar. A real herbal preventive concoction during the cold or rainy season. Another story behind it, is that not only it makes you feel better but it is also a boost to a person's health as well.

The added lightning-like pattern is to come up with the letters 'K' and 'S' which is of course self-explanatory. Those rainy days or even what you usually called stormy nights, wherein you just simply stay at home. Enjoying a cup of warm beverage like tea or ginger brew makes you feel energized and comfortable, these were the thoughts I had.

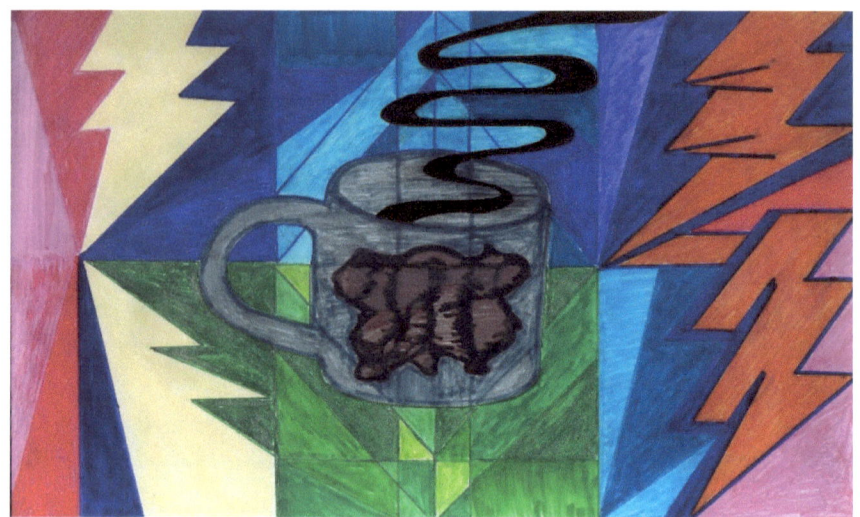

Flat Roof Houses

I had the notion of painting this image while travelling back and forth from Dammam to Al Khobar the first time. And when I was invited to a party at the roof of a villa in Sharjah. Furthermore, the times I looked out from a window on top of a high-rise flat in Dubai. In short, it is actually a mixture of pictures in my thoughts that I tried to put together like a small coloured jigsaw puzzle.

Beyond the horizon (or more specifically as a background) I have presented the dunes of the desert in yellow pattern and the stillness of the sky into blue. To put emphasis on my opinion that these places really needs more than vegetation, only three plants I

had drawn. Or is it like my subconscious mind showing how I miss the trees, the greeneries of my home country?

From the title itself, it is obvious, that the region does not have much of a rainfall at all. Meaning, the logic behind flat roofing, unlike in a place where there is abundant rainfall, snow or water which requires a steep roof. Despite the actual pastel colours or a simple combination of sand colour, beige or flat white shades of these buildings I have seen---the brilliancy of colours is done generously to add life to the modern shapes of concrete.

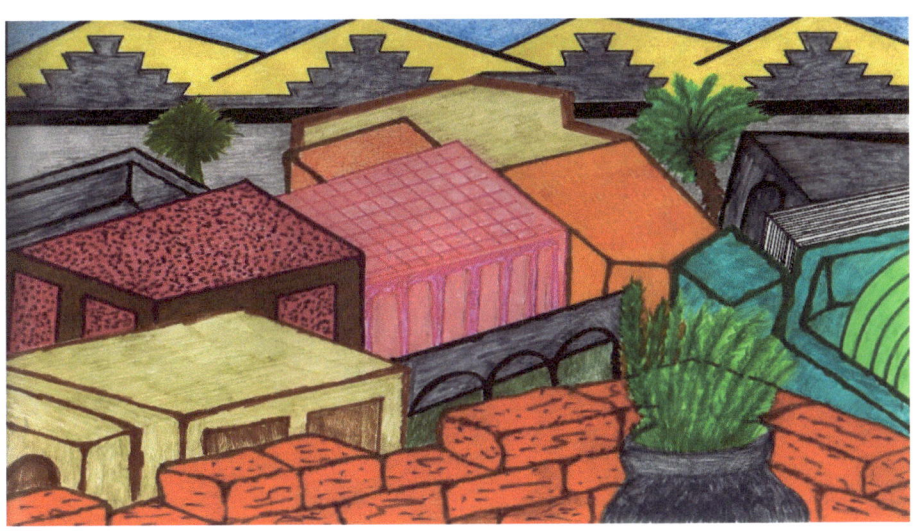

Petrified Lullaby

Petrified Lullaby is more of a commentary picture expressing ideas than an interpretation of some things unreal. It is actually titled 'petrified lullaby for the young adults' I shortened it by dropping the "for the young adults" to make it easier to remember. Besides the central point of this drawing is more of 'explosive rock' (noticed the somewhat blasting rock inside the baby bottle) lullaby for the young adult.

There are two reasons behind the baby bottle sleeping

/relaxing like an idle person or a lounging subject. One--- is to project the laxity of any person as in any moment in his life. Whether he or she resting, sleeping on a hammock, enjoying the ocean breeze along the seashore and directly under the red sun. And two-- the young adult or what we politically correctly say===the young generation relaxes, enjoys life to the fullest! Living carefree and easy, not minding the rest of the world; no worries at all as we speak!

Lullaby is just metaphorical to denote the music for the baby as well as the milk needed to nurture and provide nourishment but being petrified to mean, it has something to do with rock music.

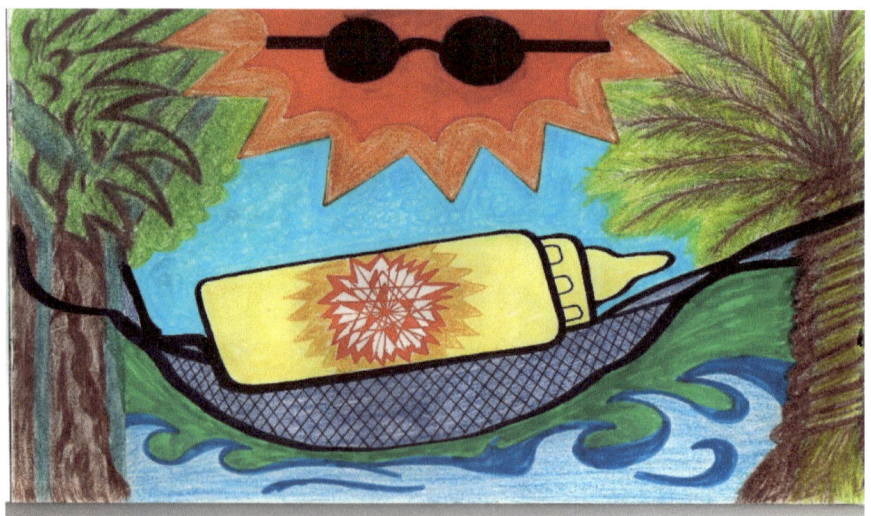

Dark Horse / Tamaraw

As much as possible I do not want to paint animated objects especially as an image subject, as I am not in a disposition, but having a very strong feeling to express what my thoughts are got a better hold of me. So in this picture, not only one animal but five and to be exact it deals with six actually. The central figure which is a horse or stallion superimposed on a tamaraw *horn (our national animal; like a wild ox /buffalo), an eagle or a falcon, a*

tiger, a lion and a giant panda-looking bear.

I will be a hypocrite if I will not accept that the message in this picture deal mostly in a patriotic or in a nationalistic way. Surprise? you may probably guessing, what are the symbolisms of these animals to connote something patriotic, nationalist or even political. Well, as mentioned on the preceding paragraph about our national animal---which is the tamaraw (though not wholly visible, the distinctive horn is).

"The beauty is in the eye of the beholder" or "A picture speak more than a thousand words", so far I have given you some of the clues already so I guess I will stick to these sayings and leave to you to decide what really is the actual message I am trying to convey here.

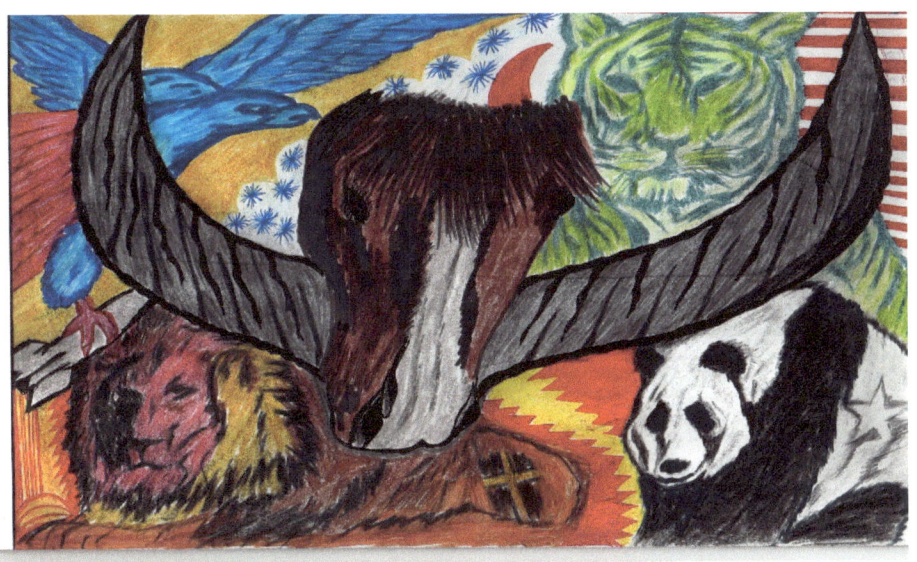

A3 Gallery

 At first I thought of naming the title of this short note as 'A7 Gallery' but adopted to a simplified modification. The notion of just adding A4 + A3 = A7 is too trivial as a title topic, as the first few images were actually drawn from A4 sketchbook until I opted for a larger space. An increase in size of the image by about one fifth of the size and more colour clarity is fair enough I guess.

 Obviously, these images are more recently done compared to the A4 drawings which some of them are dating by at least a couple of years back. You will notice as well that these new drawings are pasted in complete straight edges while some (only some) of the previous ones are having the "border". This border images I had intentionally left untouched to emphasize that all the images are drawn on a sketchbook.

 Other than shifting from small to a bigger "colour playground" I have used new and thicker colour pencils and permanent colouring pens for more intricate details. Modesty aside, another added technical feature is done on a higher picture resolution, meaning the pixels are more. Without sacrificing the resolution by multiple stretching and skewing, these images are saved on Adobe Photoshop CS5.

Feathers

 With a mind like a wanderlust reminiscing the progressive jazz tunes of the late 60's up to the early 70's I started the basic

outlines of this drawing. Sometimes even recalling the bass and synthesizer riffs of Chick Corea's RTF (Return to Forever) band on their musical piece '500 Miles High' while my fingers continued the short succession of strokes.

With the help of an actual bird feather and a sponge-like feather duster, I studied the minute details in order to project the closest resemblance of the real thing before transferring the image. As there are too many colours of feathers to show, I thought of charcoal or grey colour would suit best the lightness I want to express.

A slight tint of orange underneath the shades of red I have chosen to represent hotness in the airspace, or the extreme higher temperature of the upper layer. As I always thought of the higher you go up, there will be more sensitive feeling of heat. In the same way of contemplating that though the higher you go up into the atmosphere the colder it gets, but in reality the colder the feeling the hotter it feels. As a native northern dweller from a cold country says "as cold as hell"!

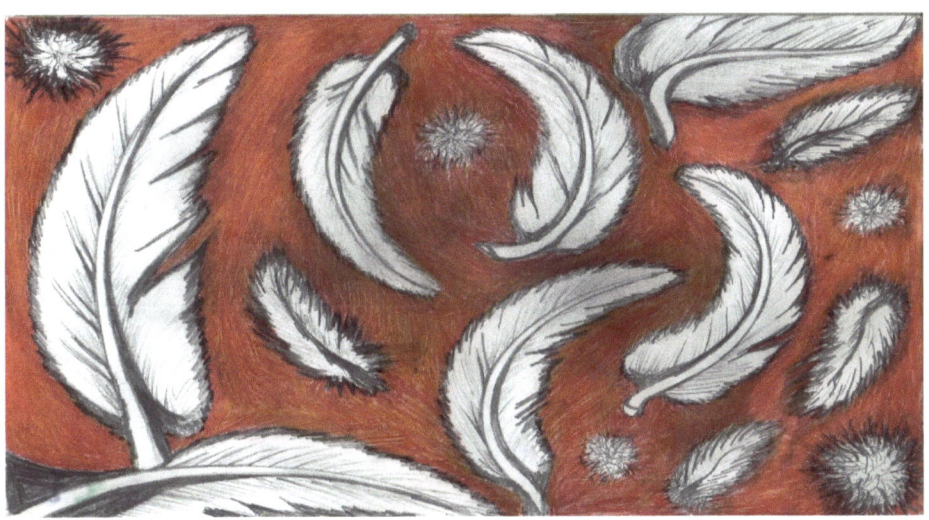

Luha Mula Sa Tala

Luha Mula Sa Tala *translated literally is 'a tear from a star' but I actually want to represent it in plural terms like--- tears from the nearest star. With a clear-cut map overlaid on our country's tricolours, a pearl- like circle (always remembering that "pearl of the orient" as another description of our motherland) on national seal-shaped primary colours; a sense of patriotism is evident here. Or perhaps my subconscious feeling of homesickness (again?) expressed.*

The shining star rightly placed at top right corner is a way of presenting, the geographical location of my native country---the south east. Complementing the three tear-shaped objects, are three orange stars (though in our flag the stars and the sun are yellow in colour). The little droplets of rain are similitude of tear drops shed because of whatever calamities challenging the economy.

Now, having describe the image at least graphically, the centre core of my expression here is that of my loose interpretation of a modern myth that our country has emerged from the nearest star. Sprinkled like stardust over the pacific until these group of islands formed into the Philippine archipelago.

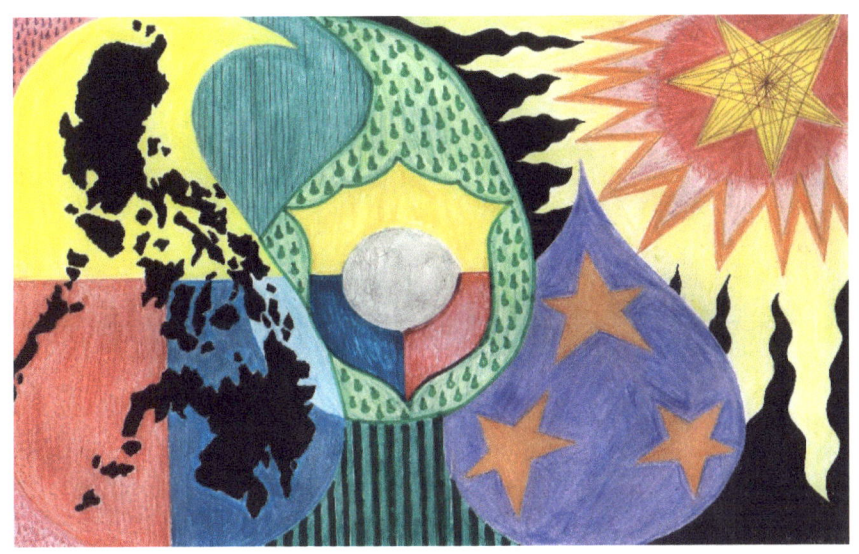

Compressed Carbon

 Not only a common proverbial knowledge that 'a diamond is a woman's best friend' but a colloquial saying 'a diamond is forever'. A materialistic attitude of man himself, who would have thought that a humble carbon compressed is the diamond!
 If anybody must have noticed, one of my common objects of symbolism is in the shape of a heart. Albeit in combination of red, pink, fuchsia, blue or charcoal grey; they are mostly shown in wounded, walled, chained or mystical wings attached.
 Starting from top left corner, clockwise---a hard walled heart reveals stability as well as security like a fortress. A heart with wings on it signifies the fleeting thoughts of fly-by-night love affair, sad to say it applies to both gender...men and women...on love-playing roles alone. A chained broken heart and the scarred one with medical plaster are so easy to define----though both are losers

in love, but still struggling to survive in a world without love.

Why are the diamonds surrounded by these hearts? a question I should have asked the ladies! but then again, I know we, men have a different logical answer but sometimes, it feels like better to shut up and listen to the ladies themselves!

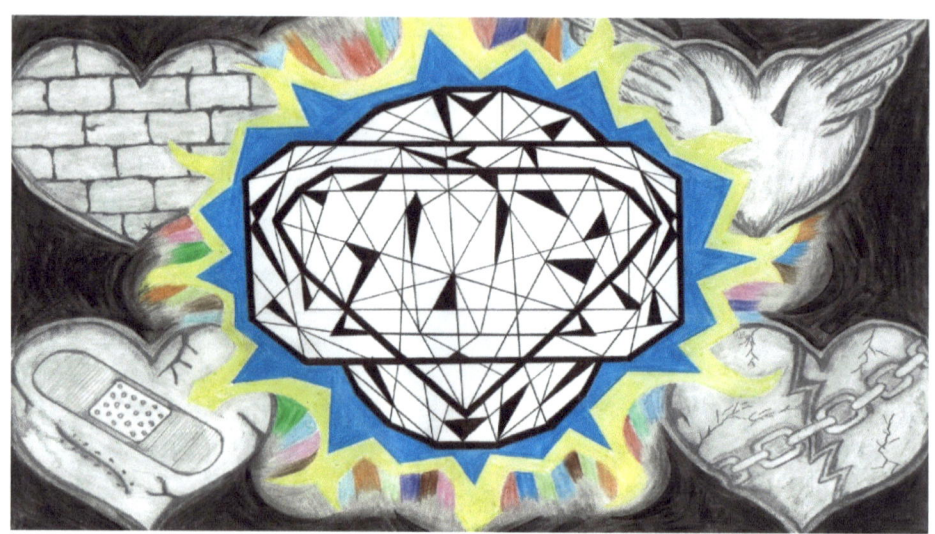

Pitik-Bulag

An idea from one of the earliest childhood game we used to play indoors or outdoors, Pitik-Bulag *(rock-paper-scissor guessing game with a different twist). Without shame, I had to admit I let my own fist, flashed a victory sign, finger-flicked and shown an open palm for my model object.*

Although a child's game, but other outright thoughts flowing for each hand gesture: The fist (rock) a poignant remembering of

people struggling from any oppression, a protest sign of freedom or from whatever hostility. The V-sign (scissors) is a universal symbol for winning, overcoming, victory, prevailing over any obstacle. A gesture to succeed since the time of history, man's forever quest to win. The open-palm (paper) is trouble less to guess but it is not only about one definition. It also holds true for surrender to win or gain. Another expression I want to convey is the search for income, when I have added a very small feature coin-like image at most bottom-right corner with plain yellow background for light significance (signifying man's never-ending quest for wealth). Lastly a monochromatic shades of green to show coolness in life with this--- the finger-flicking gesture to complete the cycle.

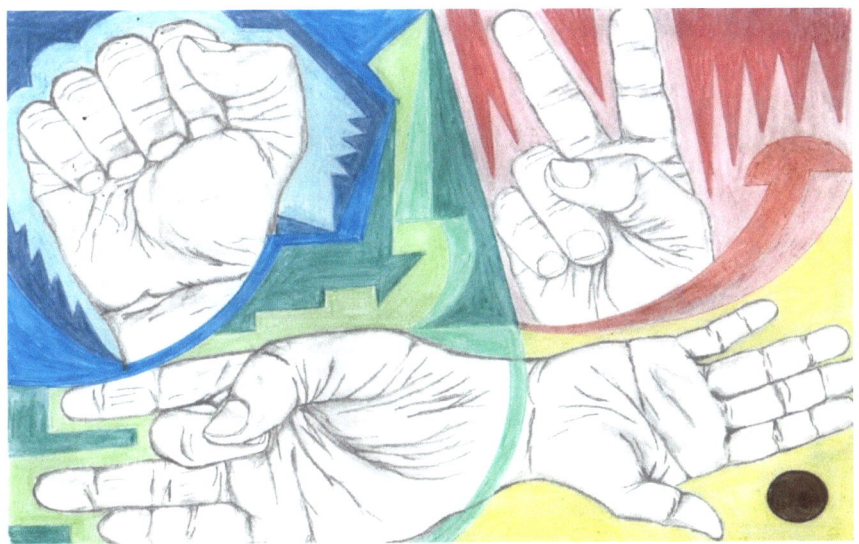

B & W

"Simplicity in life! moving forward the business of life" has evolved from my very own (honest to goodness adolescent years) old motto 'the business of life is to move forward'. And realizing

that the reality of life is not that easy, I pensively supplemented it later with 'simplicity in life' at the beginning to add more impact that--- to enjoy life...do not complicate it...live simple, free and easy, cherish life itself to the fullest.

Kindly take note that from the very plain title itself, [B & W] I gladly shortened, or abbreviated to enhance my point of view of simplicity. Everybody knows it is commonly known as "black and white", an oversimplification or just plainly clear and or finally to the point of everyone's benefit = easily understood.

But there is also a catch in this image, my sincere longing for creating an image of contrast. More importantly a play on singular hue, colour contrast and shapes, done in a "modest" abstract-like image. You cannot imagine, the feeling of short burst of happiness every time, I come up with each triangular, square, circular, or semi-round shapes being completed. What I meant is just a short sense of accomplishment to draw or paint something directly from thought.

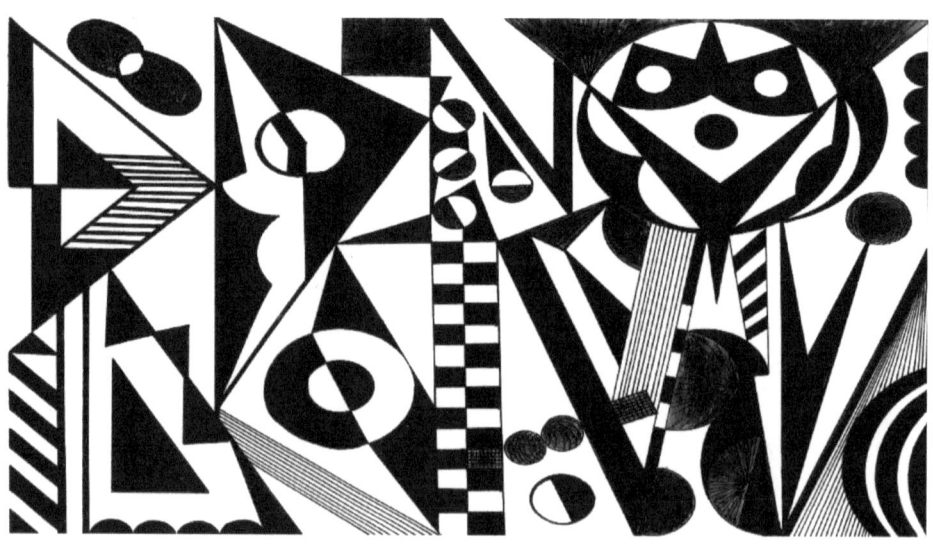

Marbles

Like any other average kid in the city neighbourhood growing up with numerous toy items such as playing cards, (perhaps in the west, the normal baseball cards) I remember playing colourful play marbles as well; small, medium and big sizes. Even the ones that used to decorate my auntie's centre table's vase.

In this image, I have tried again doodling and painting with the colouring pens, which I must say, trying hard to master the colour combination and shading techniques. Thinking that if I will not be able to paint with these colouring pens, how I would be at least try my primitive skill on watercolour painting on paper! (Trying hard, though I must say but not for now, as someone said, do not sweat the small stuff!) Just carry on with "the flow" and paint joyfully.

The original idea, I have as a background for this drawing is supposed to be earth colour or somewhat like a sandy or beige colour. But shifting my thoughts to reminiscing the hard time playing marbles, sometimes on the pavement or cemented backyard change it. As usual, playing with colours and recalling the favourite colour combination of my "leading" marble has an elated effect of happy memories of a very mundane child's play.

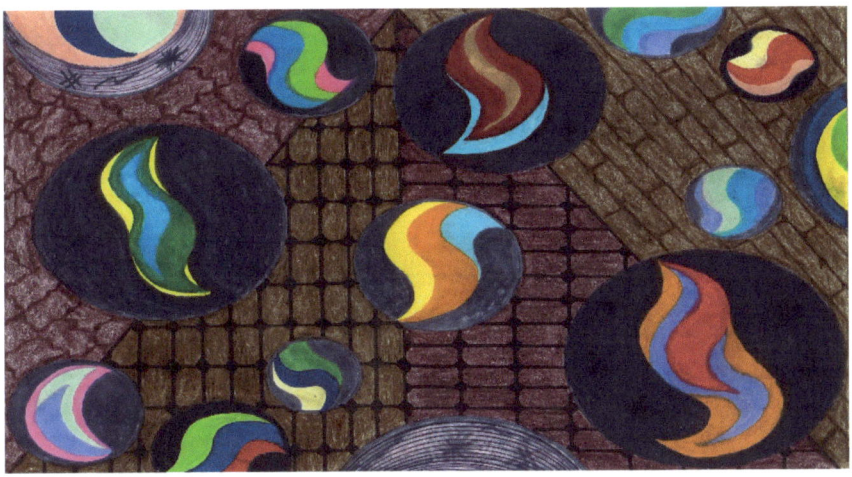

Juma Two

Juma Two is my altruistic approach in improving the earlier drawing I sketched and aptly titled as Juma One. Though both are done using only HB pencil lead and white pencil, I did try to bring out the closest resemblance to a common charcoal painting in paper. Sometimes, I would feel like having a very easy task of sketching, sharpening, rubbing the image but drawing in straight lines is a bit of both easy task and difficulty structuring the symmetry.

If you are getting familiar with my other group of images, this drawing is no exception to the group series---Pious Squares. Yes, indeed, it is like a multiplication of the pattern itself, only this time they are in sharp repetition of not exactly similar parts. In fact, the most distinguished characteristic is the collective colours of black, white and shades of grey.

Like in Juma One, the background pattern is the inside wall of a mosque, only this time I have sketched it in a different angle. The head of a man as the highest part of his body touching the ground to show a very sincere and utmost humility to the omnipotent God. And laterally the, uniformity of a prostration, the bowing, and standing up straight; all showing a full sign of respect to the one and only God.

Jungle Bamboo

 Still feeling the dry seasonal breeze in my mind while contemplating on the scenic country side where you can see beyond the horizon the silhouette of bamboo trees. And from a short distance the golden rice fields swaying to the summer soft wind in tune with the rustling of the mango tree leaves. This is the exact memory I kept in mind while drawing this image.

 Although I must admit, I am not fully satisfied with an earlier work of the same theme. The image is a part of my improvement of the earlier work titled 'Bamboo Forest', this time I tried to project at least five different bamboo patterns in addition to showing a little bit more details.

 The central figure in light brown colour is a reminder of an old bamboo tree, though already cut and have been utilized for whatever purpose, a sprouting leaves signifies it is still living and valuable. Similar to an old person still striving to be useful despite its maturity. Whilst the other green bamboo in slimmer and majestic in height, like the young people at its prime, lush and

evergreen. The leafless on top left and bottom right are like those persons tried and tested by wind of changes in their lives, but they just simply bow to the wind in order not break, hence in the end they remain strong and fortified.

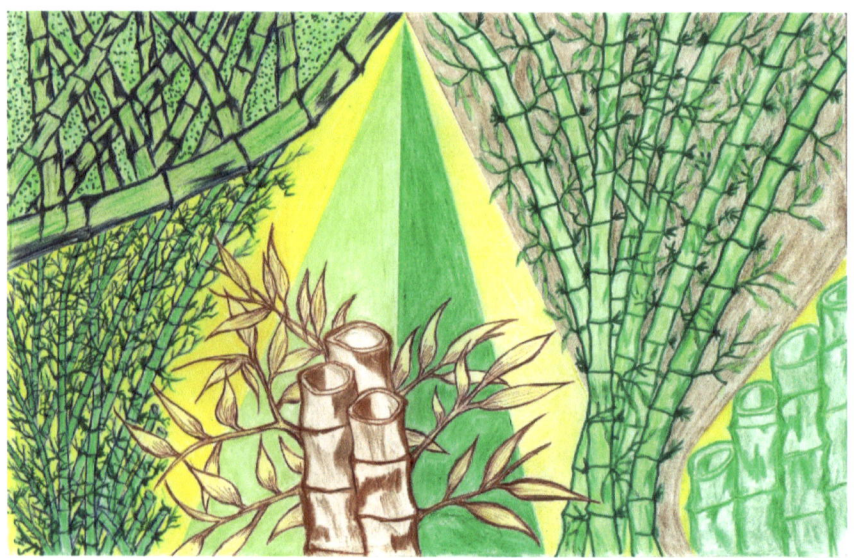

Peter Max Version

Obviously I come in a time, which I should aptly called the 'denim' generation. Who would think the lowly-humble apparel of the working class of the twentieth century will be the all-time fashion of the present generation. Young, old, male, female, rich, poor, tall, short, ugly, good-looking, slim, fat; etc... In brief this is for all people living in this modern age.

I had a bit of a hard time deciding how to name this image before I finally settle down to 'Peter Max Version' due to the fact it all started with the whole idea of simply sketching the basic blue denim shades. And with a slight of orange or yellow-gold dashes here and there in mind plus the basic copper coloured buttons or rivet like small circles.

But as I was recalling in those days, how me and my friends

got into the craze of colour patterns to our trousers. Sometimes, improvising on our own blue jeans with bright coloured textiles we can and bantering "Wow, Peter Max...living colour pardner"! We all amused ourselves and laughed about it. Reminiscing those memories that went crazy wild as well in overplaying on graphics-- resulting more of these vivid colour patches, almost overcoming the shades of faded blues!

Pink 'N' Purple

Pink 'N' Purple is one of the many ways of remembering the joyful celebration my pre-teen exposure to poster art. Like an initiation to popular art in poster series. Whatever I call it this time, I was really amazed at those posters in sight. Whether... concert poster or movie advertisement poster and all the colourful ones on tailoring shop, t-shirt or novelty stores at that time.

Having the shades of pink, fuchsia and red...this image is partly on the feminine side. Meaning, as I drew the first circular pattern (the first one on the left side) thoughts of how, those young girls with their life ahead of them, like a flower bud still about to bloom. The shaky lines and hearts reminds me of their fickle-mindedness and care free attitude.

Right at the middle, in between... is the slowly coming of age into a young woman, fresh and subtle in her ways of love. And on

the right side is the elegant, matured woman. The smoothness of the lines and shape depicts finesse. Though playfulness of a girl on the long stripes of purple and red. Numerous circular patterns of red, pink, indigo and black has a double meaning... wealth to spare or wealth of experience to share.

Coffee Dreams

There is no harm in trying to achieve your goal or dreams even if it is in a manner of wishful thinking. 'Coffee Dreams' is the most suitable title I suppose, as this image is a compilation of coffee cup logos I have been concocting in mind while dreaming of having a coffee shop of my own.

From a distance, you identify four different types of logo, with three almost identical dark brown or lighter shade of mocha. The monochrome blue on the lower right side is for what I think the future holds for this open dream.

The one in yellow background is the very core of this idea, thinking about opening a regular coffee shop. Like a break out, it is the most basic notion of having the business itself. Next to it, the one in red is like an upgrade to the next level---having the coffee shop with business lunch during daytime and a mini-stage corner for a folk singer. And lastly, the one in green pattern is for a more progressive approach of having a retro-folk cafe. Meaning it evolves now into a full blown coffee shop with elegant ambience, cosy furniture and acoustic music hits!

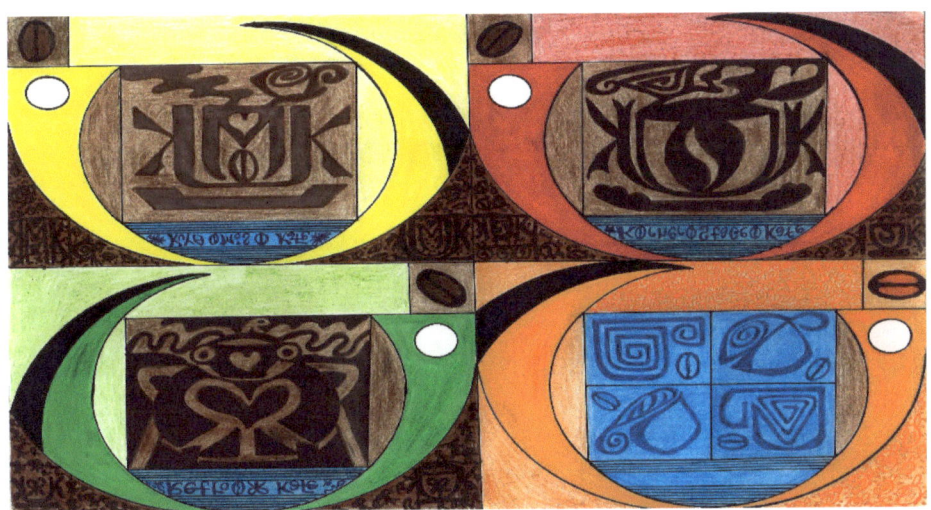

Graceful Grey

"Growing old gracefully" has been over used and under rated many times, almost to the point it has lost the strength of its meaning. Like a bland cliché, since everyone wants to be young forever! So this image is a solemn interpretation of how it feels to be in that state.

Start of a person's life is always full of life, vibrant during the primetime years. Such is the case of the circular patterns and combination of sharp angles and lines on the left side. It may continue until the early stages of young-adult life up to the middle-age. (Nowadays, there are thirty-somethings living in adolescence and fifties has become the start of life as we speak).

The central lines contrasting lines of black and white is like the turning point in a man's life, perhaps the high-time as well...All the cheerful lasting memories that lingers, with all its harmonious happenings seems like never ending.

And on the right side comes the undisputable truth of age, no matter how much we ever try, we all come to the point of accepting its fact. We age, we slow down...and this time the straight lines dominates like a fortified walls upon the stars in our hearts--- are only faded memories to live by in all its graceful greys!

Uncle Winter /Cousin Summer

"December-May love affair!" says the first viewer who commented on this image. Questions to answer in my mind---is it

because of the title, or is it because of the flowers in red against greyish weather? The simple answer is straightforward no, not at all, it is about seasons.

Speaking from the heart, it never occurred to me that idea when I was starting to sketch the outlines. Initially it was the title first that instantly popped in my mind. Similarly imagining two seasons in contrast. Like two opposing sides, hot or cold or bright or dull per se. Then thought of sketching outlines in red, blue and green combination focusing on big major subject snowflake and sun rays in the middle.

Climate changes and seasonal cycle. Winter season that cools the autumn wind, spring that gradually warms and pave way for hot summer. I guess, they are all inter-connected, each season complementing one before the other. Simply put, all about constant change of seasons and its effects on us.

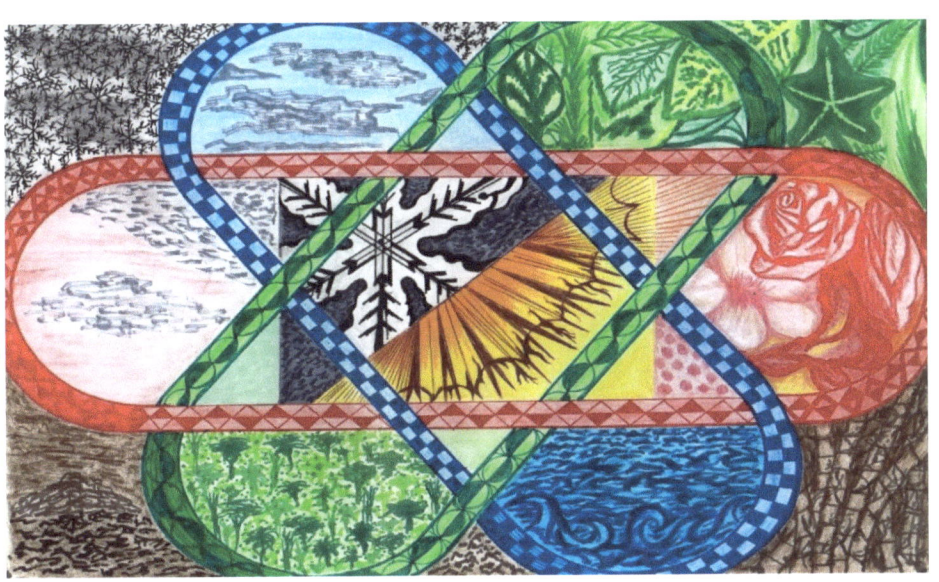

Denim Generation

Denim Generation is just the oversimplification and

improvisation of the earlier work of almost the same core pattern, though different in colour. I am referring to Peter Max Version, which I must admit I overplayed on colours, resulting another version in thought. Only this time, I really tried to stick to the basic colour of what I really intended to paint---blue. (whether dark blue, aquamarine blue, sky blue, indigo blue or faded blue).

One of the distinctive feature of this image is my accentuating lines of double stiches. Visualizing how I always prefer the double stiches on both sides (inseams or outerseams) of my jeans, corduroy slacks or even plain trousers. Obviously, it is more durable and heavy duty...meaning having a stronger stich especially on the outer leg sides.

Remembering during my teen age years, I was just beginning to wear my blue denims. Simple faded blue jeans in bell bottoms! retro-fashion coming back in a different name as: bootcut jeans...only this time, trendy-fitting well for the females. Having worn denims all my life; I wear it at home, at work, jamming or plainly chilling. Confirming I belong to this denim generation. Thus, I remain (blue-blooded) loyal to the straight-cut denim!

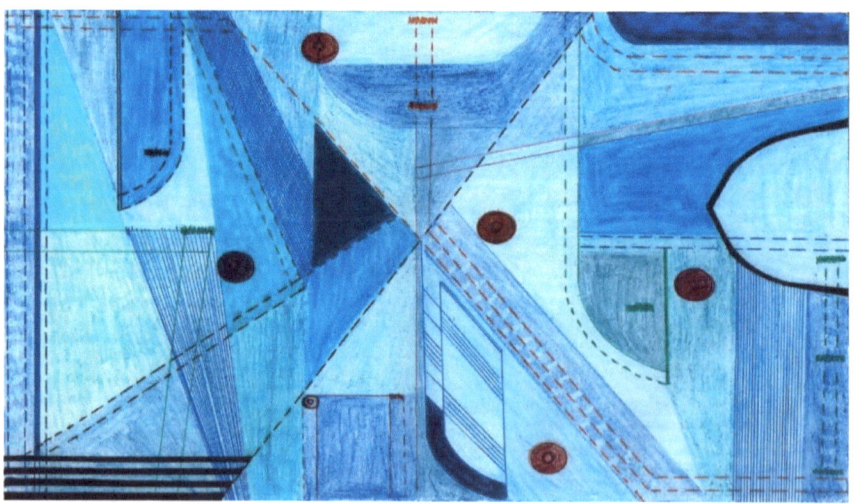

Foot Path View

Contemplating on how I plainly walk my boredom-blues

away...it is a good way of having a full concentration on life, while looking downward to the footpath. Yes, this picture is my simple celebration of thoughts of a modern man's forward approach towards life's hardness.

Those black and dark grey circles, positioned in such a way it resembles two big footmarks; are my simple interpretation of man's walk in his life. You may be thinking, and asking why in two different colour? Good to tell, that plain black is for the realistic approach to life. Whilst dark grey is for the idealistic technique. Or in a more practical way, a wise combination of both. Just like being in the middle...always in moderation, or sandwiched between two extremes.

Though the slight colouring patterns on this path are very minimalistically done, they are only symbolisms of nature's struggle against urbane modernity. I did try to sketch almost all the tile patterns I remember while walking or jogging along the foot path, without giving too much details on the greeneries or turns on the curb patterns. But what I actually want to project in these tiles are the concrete, hardship and grey treatments of life, though once in a while a bit of coloured happy moments!

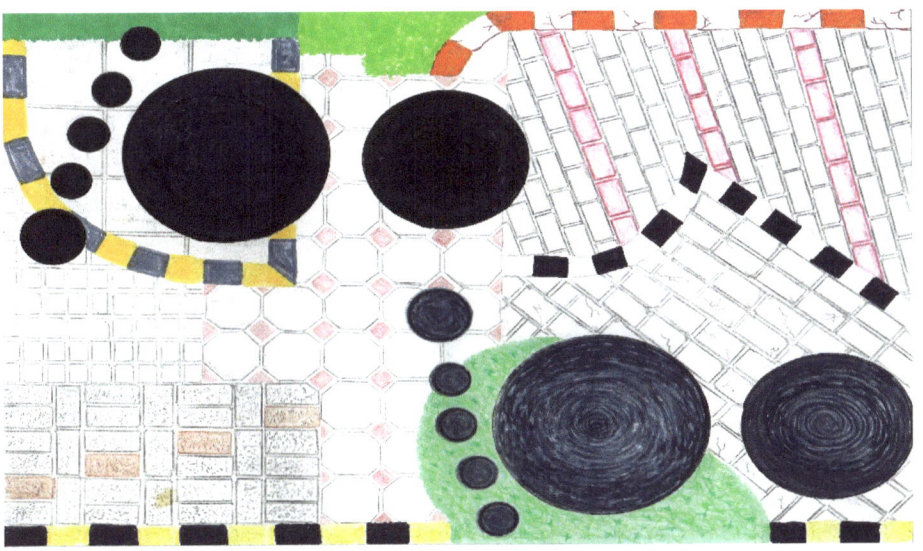

Guitar Passions

Guitar Passions is my jubilant interpretation of relax moment listening to the sound of this stringed instrument. It will not be fitting if I only mention the guitar as my major subject in this image. With the notion of naming this as 'string sensations' and vivid fond of hearing the other sounds of bass lines, acoustic nylon riffs, steel string vibratos or our very own ethnic electronified "kudyapi"!

I will be giving a discredit to the masters of this string instrument if I will not mention that I really admire their virtuosity. In fact this image is my sole homage to all of them, known or unknown, professional or amateur. At the same time showing my sincere gratitude for their contribution to art-playing or just jamming along.

A little bit of technical and abstract background---the upper picture is patterned on my Lumanog nylon string. The cello like instrument is my joyful interpretation of how I am always keen to hear the bass lines on any tune, accompanied or solo. While the lower portion in usual half-guitar in opposite direction was patterned on my China-made student steel string. Lastly, the abstract colours of cello like and guitar body hole (notice the odd number of strings in five to emphasize peculiarity), is for the happy moments of simply playing with time and savouring the sound.

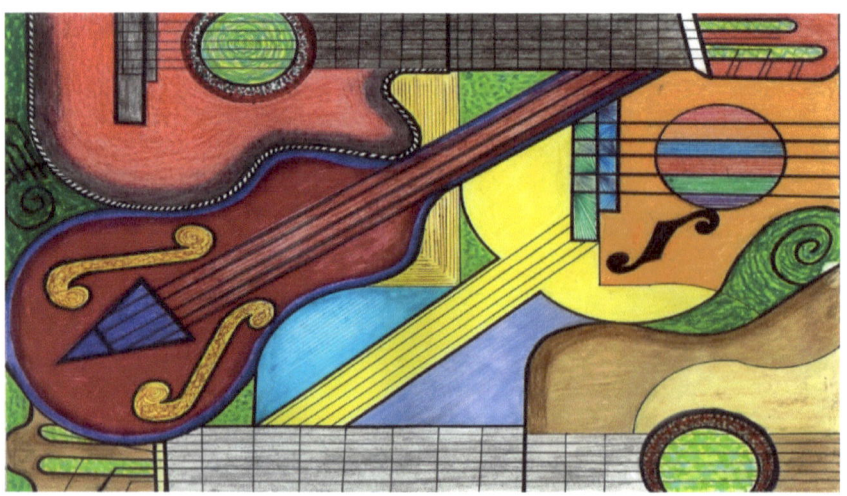

Contrast

 This image is the last in chronological order of when it was done for this e-booklet. Completing more than fifty picture-images all in. Appropriately titled---Contrast, to put emphasis on the irony two parallel things, ideas or events. A little bit like paradoxically speaking, ending but with the point of beginning. In my opinionated idea, I have matched two opposing different colour with each other.
 Commencing from the top most layer of parallel pattern of red and white---a continued straight pattern of red and white lines (including squares and rectangles) is like a structured life in its utmost rigidity. With all its best-laid plans and model aspirations, but still in the end looking at it in a bird's eye view, it is still romantically dull in pink absurdity.
 The middle layer of black and yellow is for the intertwining destinies. Dark fate or shining glory of life weaving in its ever complex occurrence. Without the other one is not distinct. And finally, the upward and downward strokes of violet or lilac overlapping the shades of dark and light green. Two prominent secondary colours dancing like sharp fangs, apexes, stalactite-stalagmite formations or up and down strokes. Sharply contrasting each other but wholly complementing as well.

5	**Group Series**

Connection Factor

 Unlike the preceding chapter---Individual images, this chapter Group series has two major differences other than by classifying it as one ensemble. One---is the relative connection between each image in the group. And the other one is the thematic style it has been presented; whether in the underlying message that it conveys, a simple colour pattern, familiarity of subject or objects, and the ever playful strokes of colours for each drawing.

 I have given a specific series title for each group of images to identify them accordingly. Though each drawing is actually not in serial number-wise in catalogue numbering, I tried to present the earliest work I had done as much as possible. This is due to the fact that sometimes, one particular drawing has been done earlier and the final related image has been done only recently or vice versa.

 I was thinking of giving a short note on each group series title but decided not to. And instead just put each group title at the centre margin, as the title itself provides at least a short definition for the images.

E.B's Dream Series

Highway 68

 Highway 68 is the second image I drew in chronological order of this series but since there is a hidden reason behind it (which you will come to know later on) why I have chosen it as the first, of course this is in connection with the other two drawings.

 The thoughts of having an abundant sunshine (a hairy or an old sun with encompassing rays) and at the middle of a highway (travelling days are not yet over) is clearly stated here. Though the

smaller objects are collated in a way that surrounds the central figure which is the highway and the bearded sun with sunglasses; they are all inter-related.

Clockwise--- from the neon lights lighting which I thought of as those fake preachers lost and his followers falling into an oblivion, then onto the conservative elite leaders is the bearded bright blue crescent at the dark side of the night sky. Towards the flying sun, which I literally and pictorially translated 'flying days or fast pace of time'. The mouth is actually a shout or cry of the people suffering either from poverty, problem or a call for help and last but not the least on the left corner the bulb which is an overused sign of the idea for the solution.

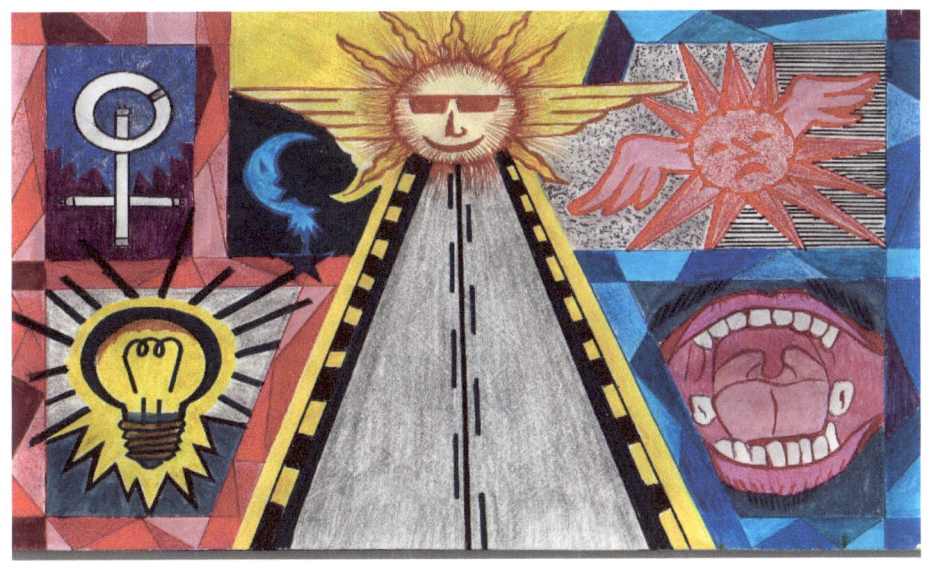

Iron Butterfly

It is hard to imagine that I would not be able to put the thoughts, at the time I was about to draw this picture. Since it is partly a dream-like image and at the same time an inspiration I have got purely from a favourite tune. As well as the spacing problem of sketching the entire thought into an A4 will be a real

challenge (That is when I finally decided to try painting my thoughts like this in group series).

The single eye is the narrator of the dramatic scene which is like a dream-like sequence of a rainy night raindrops turning into tears. With the next scene being shadow figures of a man chasing another with a blade in hand. (A nightmare? a result from watching mystery-suspense movie on DVD?)

Anyhow, the blue pouting mask reveals the intensity of the scene that was going on right before his eyes. Then, the dream sequence continue to become a floating butterfly with a bicycle shaped tails or wheels as its extended wings.

The text-like figures on both sides of yellow lightning enclosed by orange borders are only a part of hidden reason which I stated earlier. Sound suspenseful? no, it's only a part of the guessing game I had prepared for the viewer of this series!

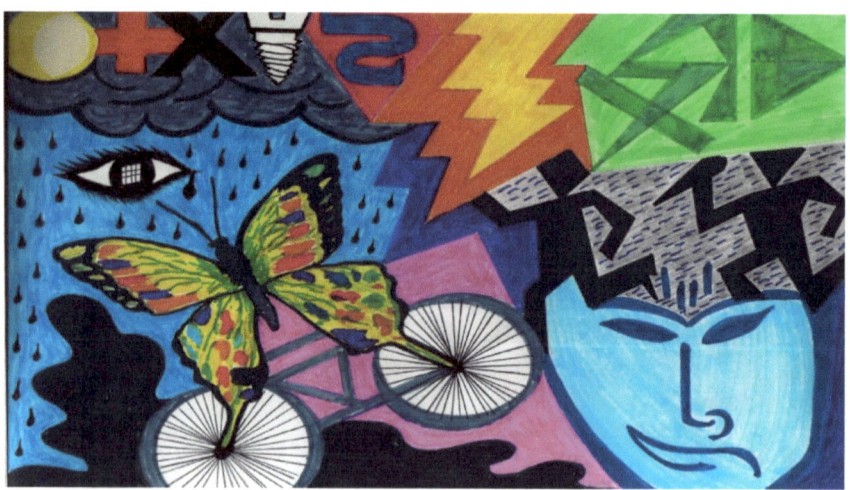

Tony Avenue

Since this is the last part image of this series, I had to say, I must admit I was quite surprised to find out the distance of time from this drawing to the very first one (Iron Butterfly) --- a lengthy

almost two years apart! For whatever reason involved why it took me that much time, I don't remember at all. I just think of this as a hobby, so whenever the thoughts or notion comes flowing, it goes.

To start with, this iconic huge face of a motorist grinning widely to a traffic officer or a police patrol (notice a bottle of something on his right hand at his backside) is a bit sensitive...but it is just a dream. I should say a surrealistic view, especially when the car itself is looking fierce ignoring, the dead pedestrian (not shown...sketchbook space problem that I missed on my part).

The backward text on top and bottom is easy to read, it is like a giveaway to the guessing game. Now, maybe by this time you must be knowing the hidden reason why I had organize it this way. Now, for the guessing game: what is the title track of the song (n.b. of the local rock band which I must say, shamelessly say trip on listening to the pop rock of the nineties!) I had mentioned earlier? Clues are already shown on each drawing, all you have to do is juggle these three images in front of the mirror!

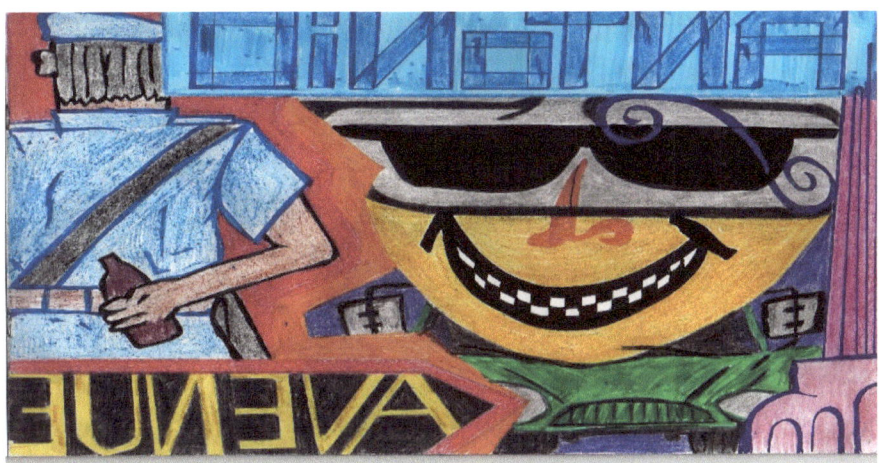

Vicious Triangle Series

Cerebral Crunch

 For those people who are usually called having a sweet tooth, this image is not a new name for special type of dessert or generally desired native afters. But rather a play on words that has something to do with the credit crunch. A personal opinion on the experiences and of how and when somebody is trapped with this modern day dilemma. Money problems, financial trouble or even the common indebtedness.

 Generally, people would say something like having a normal headache, a simple migraine to hide the fact of what causes it. The underlying truth of a terrible feeling like being 'crunched' in the head! A very horrible predicament, wherein you feel like your head is gripped by a mechanical vise. And despite of finding one of the ways of handling it, like drowning the suffering through music...the pain does not go away. And sometimes, your brain feels like being sliced minute by minute by these monster credit card liabilities!

 Inside the combination of heart-shaped and triangular walls, the raised-up hand seems to gesture... stop or help. Not to forget the yelling inside to stop this drill-like pain into the brain, whenever one's money problem arises again. Tragic enough to say but it is the truth.

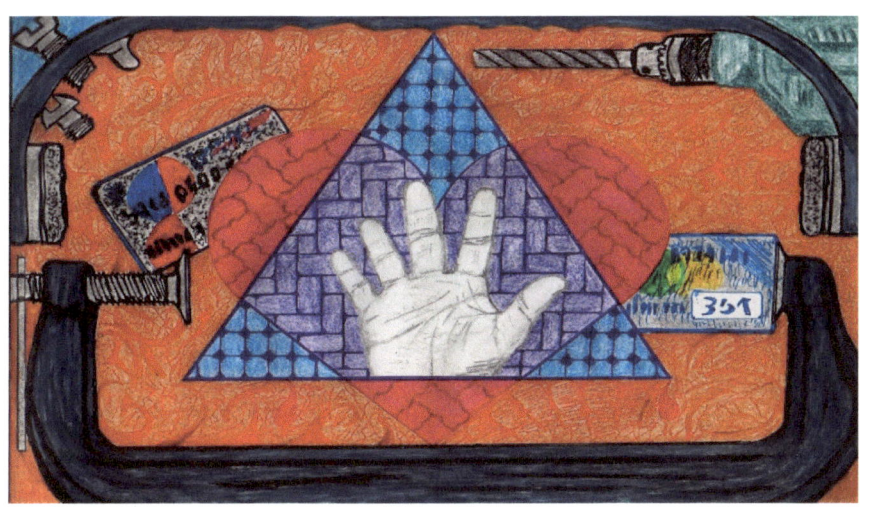

Bittersweet Memories

 From the financial anxiety of the previous image (Cerebral Crunch) we now go to a lesser 'mind hostility'---Bittersweet Memories. Being easily perceived, this image has to offer more of relief than pain. Though, ironically the word "bitter" is still stuck in there, thus without a doubt a man's difficulty is still a part of the situation.
 I can start this description by saying the medical plaster/bandage on its bleeding triangle is not enough to stop the pain from a wounded heart. A heart filled with scars of a long lost love, like a wounded loner longing for companionship. A heart of a lover still searching for a soul mate by loving and losing. And stiches from the past wounds of a hopeless romantic with undying affection that never heals.
 Sad memories that lingers every time you hear a recognizable tune, a soothing ballad or a love song, a popular classic tunes replayed on the radio, or a sweet string melody of the guitars at night. The things or fad gadgets of the past that evoked emotional

pain. And sometimes even the retro-fashion RTW that has come back brought bittersweet memories feeling of dejavu-like master blast from the past!

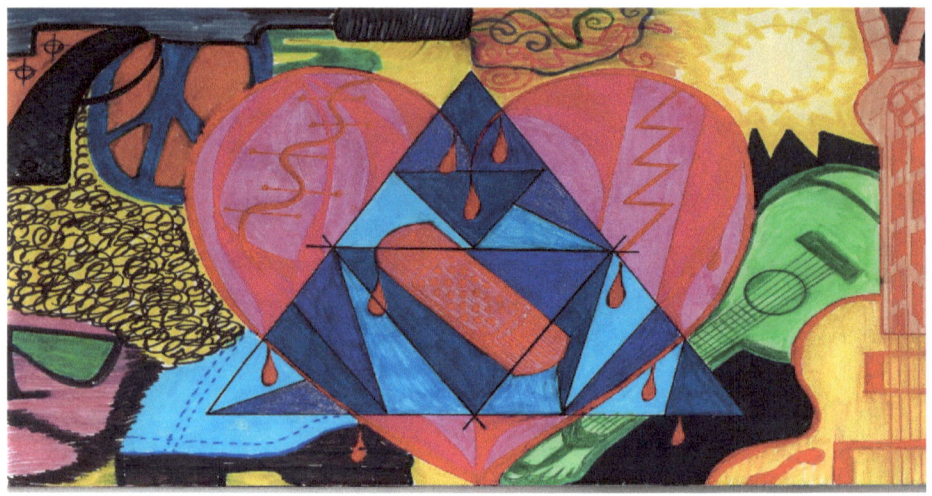

Traumatic Twitch

 Traumatic Twitch is the last image of this series, it may serve as a collection of the sudden push, pull or reminder, punch to the memory or a shocking feeling of helplessness when caged in triangular prison of loveless freedom. Either by living in a world of luxury and fame but not having a liberty even to the point of going outside the self-imposed prison bars. Or living a very normal life in outside appearance but within inside, the strange feeling of loneliness in a loveless life.
 To make it a little bit contradicting to the usual routine, (counter clockwise from top right) I started with a land telephone line that every time it rings, is like a breaking point of the brain exploding. Likewise with the cellular phone startle that hits like a hammer on the head. And the flying lips---promises that are always broken are only flying kisses of those lying lips, full of deceit.
 Although time and time again, a caged bird signifies life without liberty, like a human being living a miserable life inside the

walls of a hardened heart. And like an animal inside a cage, a man's existence is just breathing to exist; absolutely no living or life at all, like a living death. With only the blue hearts as companions to sing the chorus of the jailbird blues.

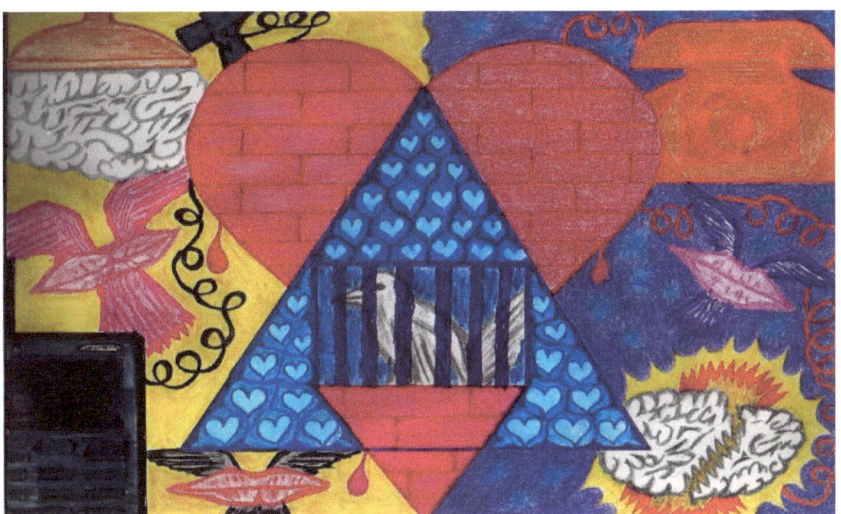

Rainbow Series

Bahag-haring Diwata

Loose translation in English is 'rainbow fairy' but if we take the literal meaning--- Bahag-haring Diwata *is 'the king's G-string*

fairy'! What a very in-appropriate name for a poor fairy, if named so, she might have turned the majestic king into a kingfisher. Anyway, in our language, a rainbow in the sky, attributing a higher place (e.g. sky) and perhaps resembling the lower garment, could be the probable origin of the word.

The main reason why I drew this image, I must say, it is my own rendition of a poster of a woman's face with vertical rainbow colours acting as a background. I recollected the actual image from memory, and was seen pasted on the wall of our neighbour's landlord son...a long time ago, say when I was in my pre-adolescent years.

A lot of improvisation had done when I conceptualize the image: two different eyes, the outline of the eyebrows and nose are distinctively different, made a fuller lips (kissable lips? facial modification for a woman nowadays; considering the extent of vanity of a cosmetic surgery). As the rainbow colours are in interwoven patterns and shades, an additional fuchsia, dark blue, and yellow ochre at the bottom are added to compliment the triangular shape of hair.

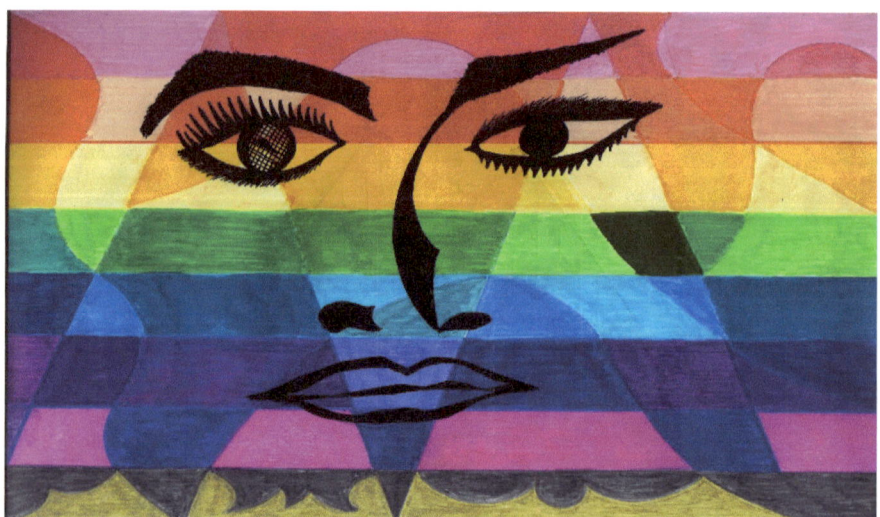

Cosmic Burst

An all-the-way experimenting of colouring pens is something like a free-for-all explosion of colour in this image. Meaning, like a child playing with all the colours he wishes, I have painted it in such delightful manner. Smiling brightly like the yellow tints while painting the rainbow pattern outlines.

Initially, I was thinking of a galaxy-like pattern with full colours exploding in different direction, with scattered minute stars as a background. But, the child-like playfulness on colour has a better gripped on me. Besides, I wanted a simpler rainbow pattern not a milky-way galaxy type and I know I would not be able to project my thoughts well, of a full explosion of colour if I did that (galaxy type).

Reiterating what I have said on the first paragraph, this image is like myself playing on colours, at the same time reminiscing how happy the younger years are, when you have no troubles at all. The thoughts of happy moments when a child on his own playground, totally immersed with imaginations. You will notice this when a child is on his/her own monologue while playing alone!

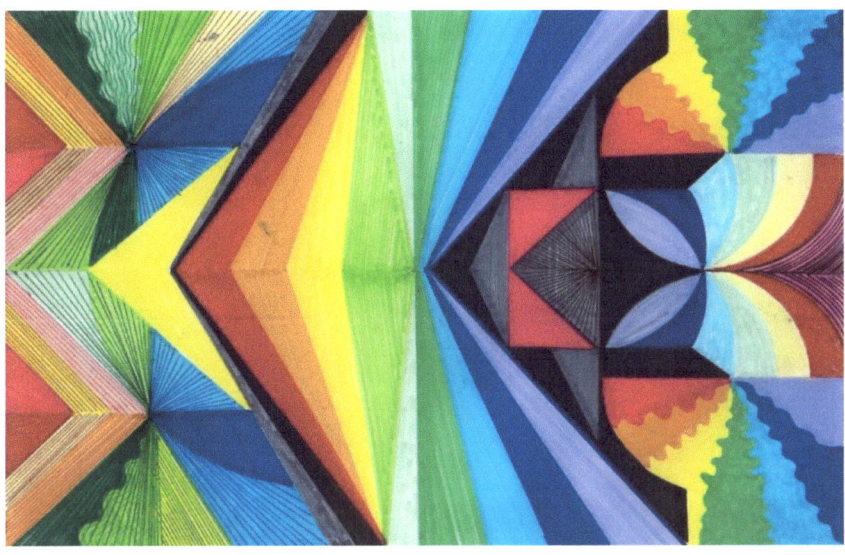

King's G-Strings

In fairness to the king and the fairy herself, I tried to transform the very least literal translation in painting this drawing. But this time more of patriarchal and showing of the king's vast domain. With a very distinctive symbol of kingship---the towering dignity of the king's jewelled headdress is placed uprightly over the vertical rainbow.

Starting from the left side this time, the dark weather clouds looming over the modern skyscrapers, symbolizing modern-monarchy in time of turmoil. Despite its highly civilized culture, cosmopolitan society and advance technology; the future and horizon does not possess a very bright aspect.

On the other side of the picture and in contrast with opposite side, is seems the sun itself giving its warm blessing for a bright sunny day and promises for a peaceful pleasant days ahead. Coupled with the nature-like brown green mountains, hills, waterfalls and lakes. What a perfect setting for a man's appreciation of nature. All the citizen as well as denizen are living harmoniously.

And finally it all ends with the complete control of the king, these lines or strings, is the signification of his sovereignty despite the odds, balance of power, socio-economic or political unrest.

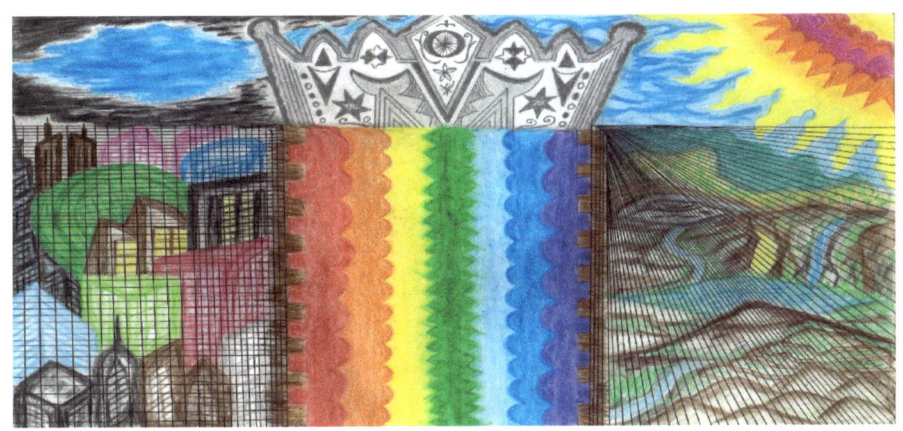

Pious Squares Series

Mideastern Sun

 Mideastern Sun is not all about middle east sun, the dry desert, rocky hills, caves, coastal waters or even wadis (rocky watercourses that are usually dry except during rainy season). It's my humble homage to the people of the region. It is also a celebrated thought of seeing personally for the first time, multitude people of different nationalities in unified manner of prostration, bowing and standing in humility to praise, give thanks, ask forgiveness from the Almighty God.
 The central background image of an enormous sun in almost full shining yellow colour depicts that the region itself has an abundant sunshine all year round. A way of enhancing the thought of a hot (blistering hot!) climate especially during summer season. Can you imagine an average thirty nine to forty degrees Celsius [my rough estimate of the outside temperature]?
 Like the other two images in series, the two constant object or

subjects are the Kaaba at Mecca (square black and grey colour) and obvious pattern of squares in each designated postures. Whilst colouring a few dark green spots on bright yellow green to represent the green patches of greeneries of the region. And the wavy shades of blue, light blue and dark blue for the coastal waters.

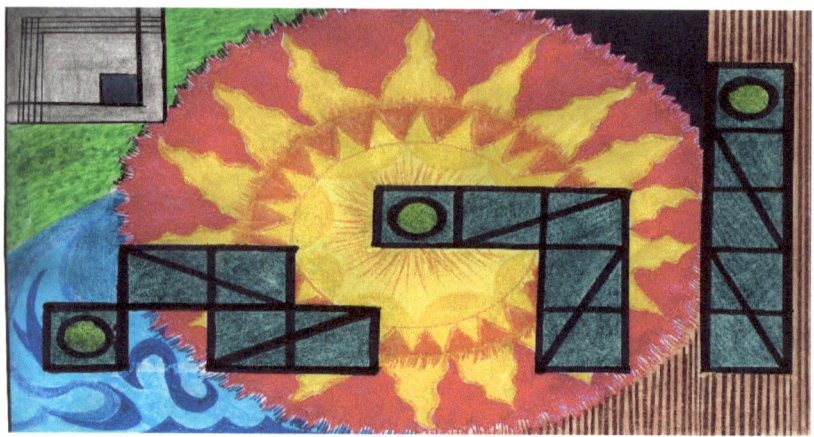

Zamboanga Float

To our brothers in Mindanao in southern Philippines, this image is a tributary expression of brotherly love. At the same time, the respect and pride for their cultural heritage. Zamboanga Float is not only a place but a celebration of colours with their vivid combination on the sails of their vintas.

Remembering my first trip outside of Luzon by inter-island boat, travelling to Cebu, then to GenSan up to Davao City...These are the thoughts on my mind as I drew the teal and blue colours of the constant waves...up on the upper deck...what a beautiful day...with a clear blue sky and the shining sun at the horizon....memories that are so cherished like a "maiden voyage" (just in time to hear the cool modern jazz sound of Herbie Hancock's tune of the same name).

Right at the backside (of the vinta), I have included a windy

rain-like showers, but in reality when I was drawing this, the thoughts of a drizzle, foggy misty morning and the breath of fresh sea air occupying my mind. And the palm tree reminds me of the long stretch of coconuts, palm trees and mangroves along the shore. What a beautiful and very exciting sight to see for a young boy!

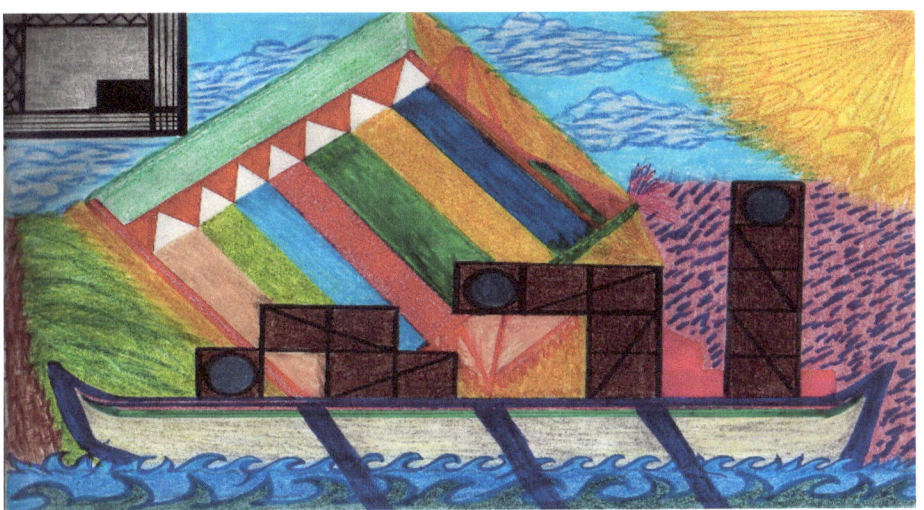

Tropical Moon

 With all due respect to the people of world, whether from far up north or southernmost distance from the tropics---this image is for them, whoever, wherever and whatever social status they are. In short it is for all the human being. I say again...human being with full respect. Regardless of colour, race, religion or nationality, rich or poor as they are all part of humanity.
 Despite all the global inflation, disaster, wars, famine, social or political upheaval and decaying moral integrity challenging some parts of the world; To cheer up and give a positive outlook, I tried to colour the full moon in extreme bright yellow, almost like sunshine yellow; to be optimistic that all these hardships will soon be over. A promise of a bright new day in the days to come to bring

in peace, tribal harmony, economic growth, stability and security.

You will notice streams, trees, evergreen lush plants and tropical flowers I had depicted in my drawings (a short advance notice of 'Flowers of Joy' to come later in series) for a real 'Tropicana' effect as we speak. Without forgetting the bamboo and mangoes to compliment the whole tropical picture. Finally, I have included blue skylight and grey dome to add a sense of modernity.

Lotus Series

Lotus Blooms

Have you ever imagine experiencing a dream wherein you are surrounded by lotuses at their fullest bloom? Serenity is not the only peaceful feeling as your companion but also an explosion of red, pink, green, orange, violet and blue. And the tranquil feeling of being like a part of them. This is the image I am trying to express, although it was a recollected thoughts from a dream; it feels like being on it again as if like it was real.

Albeit there are more red and yellow lotus in my thoughts , I have intentionally painted the central lotus in yellow and orange as I have a strong to the gut feeling that this colour suits best this flower. Especially when it is already in full bloom, like a yoga practitioner in lotus position. And it also reminds me of the yoga instructor in our neighbourhood. What a silent type of a man! in my young observative mind at that time.

Speaking of silent type, shy, or timid personalities---these are the people I have dedicated this image, in fairness to them, they may have a lot of reasons to be, for which we do not know at all. They may not be talking at all, but they listen attentively and speak out only if spoken to. Who knows? it is not about attitude but it must be their personal laissez-faire!

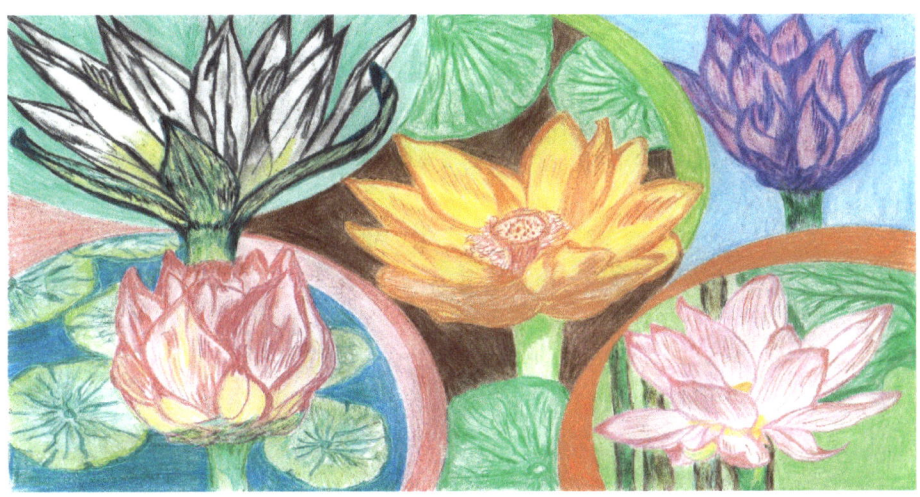

Lotus Grey

 Lotus Grey is the representation of the preceding image in my playful mood of drawing in black and white again. Like a mini-charcoal painting on paper, it reminds me of the street artists I have seen during my travels to Dubai.
 The thoughts of growing old gracefully has occupied my mind when I started to draw the outlines up to the finishing touches. Without doubt, people age, some grow old wisely and with grace (though it's just a cliché) others simply fades away like colourless blooms. Here is my principal point of view, though each personality with colourful past will soon fades like this. Scars, forehead lines, crow's feet, eye bags and even bony hands never fail to show age, but like blooming lotuses in grey and at their own intricate lines.
 Still on shyness or just being tight-lipped, I pay respect to my grandfather who was like one of this lotuses. Having a colourful past, was an active as sportsman, (through my grandma's evening stories, when she used to narrate that he played softball games) His peers called him "lead", why the nickname? I ask grandmother, is it because of his restraining emotion or speech, the silent-type who has grown old gracefully?

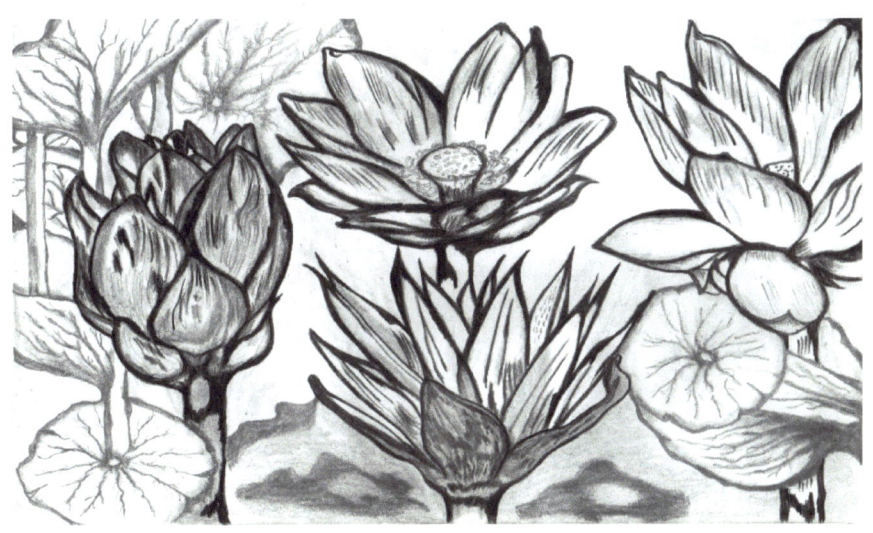

Lotus

Now... fast forward to present day--- From the wild turbulent times of the hippies to the new age young urban professional (yuppies)? Then to the metrosexual fashionistas up to the technical savvy ultra-generation XYZ? Although partly this drawing is a culmination of the thoughts I have for the previous two images, this single lotus represent man's utmost yearning for recognition.

Like the subject lotus at the middle, with petals like arms or tentacles reaching outwardly for sunshine or touch with the surroundings. Similar to a person amidst a crowd, circle of friends or even among his kin or society; he yearns and long for recognition. Not the kind of blatant wanting to be at the centre of attraction or dull sense showing its own existence literally, but at least a subtle feeling of being worth to be recognize.

So, I did painted the lotus red to emphasize the liveliness coupled with the uneven shaped of yellow and orange halo around for clear instant attraction. Having said that, these colours are all in contrast with the green or greenish background. Likewise a man wanting, needing to be surrounded by objects or the conditions all relative for him to come out...outstanding!

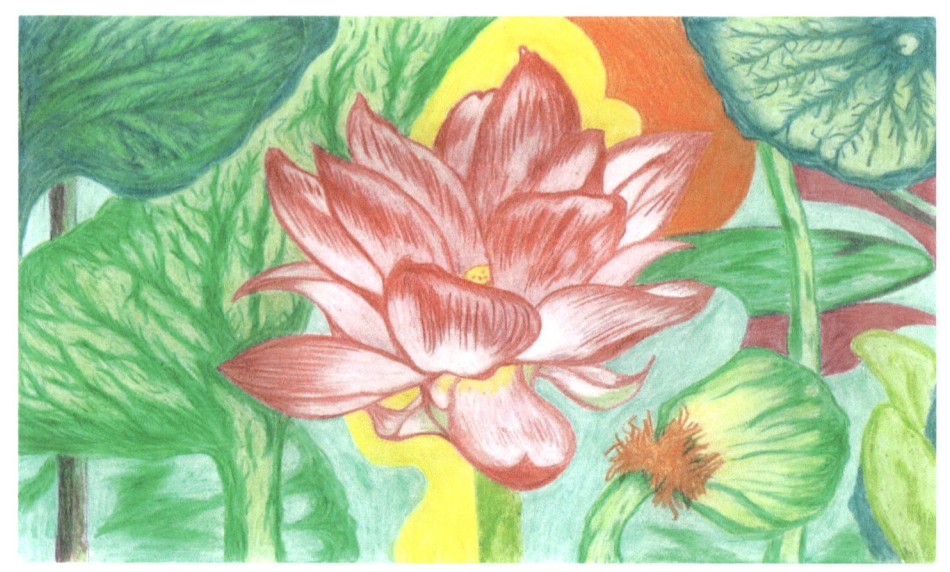

In Blue Series

Blue Violet

 I have always been fascinated with these two colours even when I was still a child scribbling with crayons. I remember experimenting with them by overlaying yellow colour (incidentally yellow has been like my all-time favourite) to come up with my own shades of green. Though with the violet I do not exactly remember what came up as I know purple is already a secondary type of colour between red and blue.
 From the overall look of this image, it clearly shows that I have presented dark blue in minimal form. Without a doubt I tried to conceive an outcome of indigo by combining blue and violet by even playfully assorting contrasts, soft curves and straight lines of it. Hoping I would come up with an abstract-like form of art (modesty aside, humbly I still consider it not a true form of abstract work of art).
 Although in fact, I am now ready to admit that I am beginning to like this image more than the other drawing of the same style. What I am trying to say is that the more I frequently look at this

picture, the more I appreciate it (sorry for banging my own drum machine, but this is just how I felt). A feeling of an egoistic happiness that I was able to express my thoughts and at the same time amuse myself light-heartedly with these two strong colours.

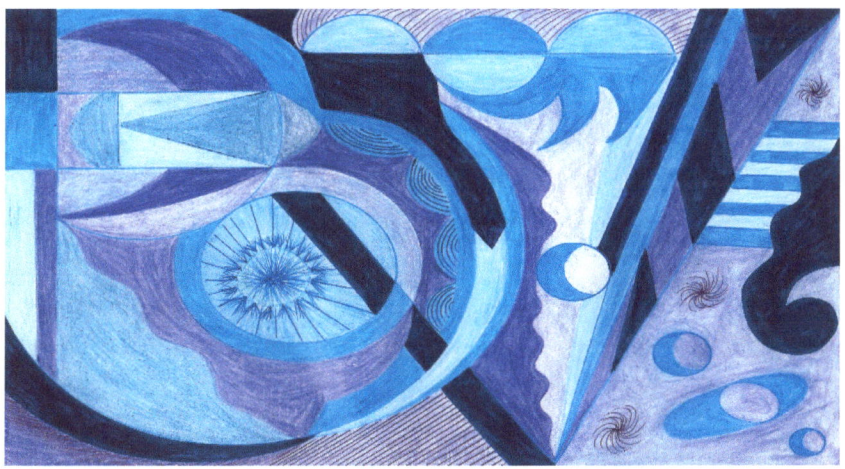

Blue Moondance

Imagining two lovers under a pale blue moonlight caressing each other only the swaying of the palm trees, mango groves and coconut leaves as muted witnesses. With all the balmy kind of cool breeze complimenting a true tropical-paradise scene! This is the main object of this image I want to convey.

While Neil Young's "Harvest Moon" playing on my stereo, it was a double-delight drawing this picture. Inspiration being injected while shading the halo-like combination of light blue and very light aquamarine blue to the roundness of the full moon. Adding scattered tiny bits of asterisks-like blue (utilizing just a common ball-point pen with short strikes over the light and dark grey shades to project an image of countless number of stars above the night sky.

I would be a hypocrite if I should not accept that it was also inspired by Michael Buble's soft swing melodic version of "Moon

Dance" (a Van Morrison classic) while working on this image. I must say as a kind of friendly advice, if you are more inspired with whatever type of music you are into, you could listen while painting...that's speaking from my ever "hopeless romantic heart"!

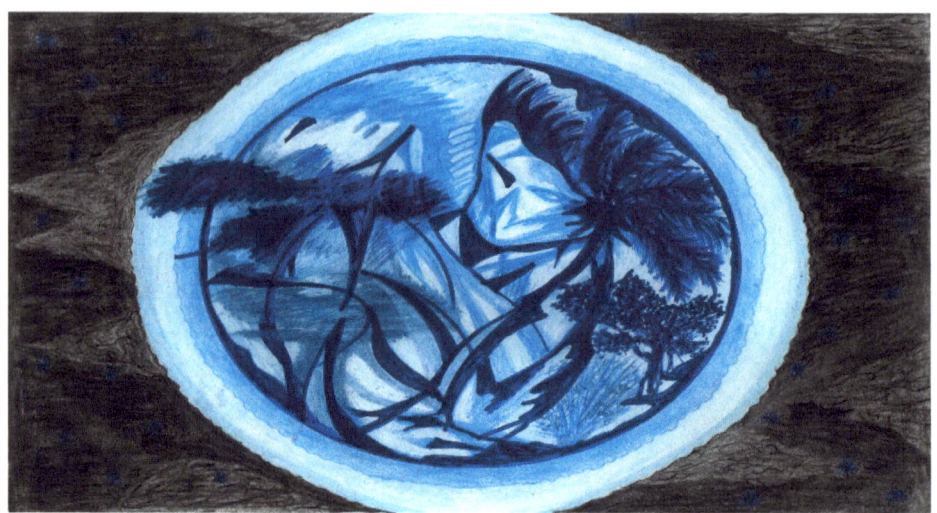

Blue Green

 Blue Green is another playful experimentation of the colour blue, only this time with the ever cool tint of green. A rapid helter-skelter feeling of combining two things, opinions, ideas or movements. Like in today's world --- everything in fast motion, people in a rat race, always urgent timings, exacerbated by fast consumer goods; life for everyone is in a hurry sadly enough sometimes in a disorderly state.
 Burst of memories of my pre-teen age past, I remember the early days of learning to decide on my own fashion style. In brief I was just starting to be conscious about teen-age grooming and learning the ropes to be part of the "in" crowd. There was this tailoring shop in our locality named 'Blue and Green', with its lighted blue and green neon light signboard and even the big logo at their main door beside their showcase looked fabulous to me!

The spiral-like combination of blue and green intermittently flowing at the bottom right side was actually the very first shape object I have in mind when I was just starting to do the outlines. This is my way of symbolizing motion and swift action. And at the same time a half-like pattern of broken arrow at the top right corner, in logical continuity expressing man's activity towards his goal in a hurried confusion.

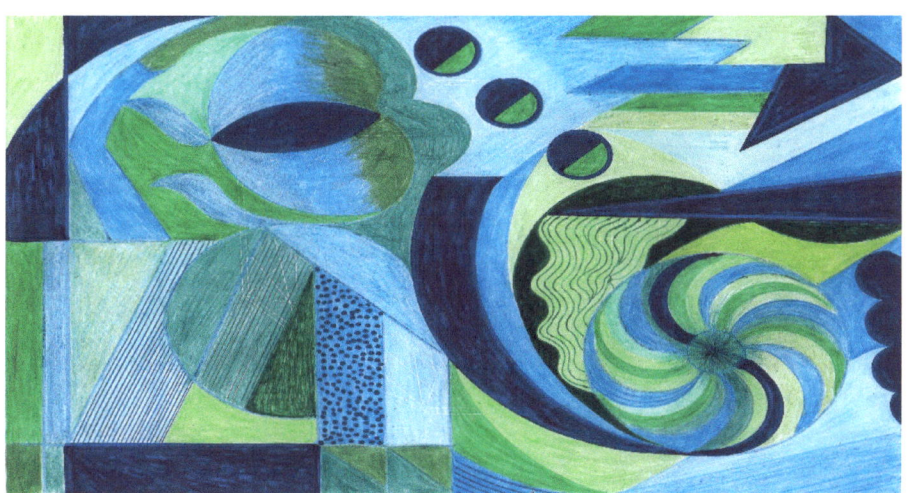

Pacific Blue

Engaging in festivities in a tropical environment is no easy task. Especially when you tried to participate in all summer activities; from swimming, snorkelling, walking along beaches to

hiking, mountain-biking, picnicking and even up to nature-tripping. Fun and merriment will always be a part, like a whole sunshine bloom after a rainy day.

But why in blue? Well, to be perfectly honest, it is something to do with the completion of this series. After finishing the first three images, thoughts of a sun in blue while reminiscing the summer holidays in a tropical region; I decided to include this drawing. Furthermore, the initial title of this image was actually 'tropical blue over the pacific', but aptly shortened it to Pacific Blue.

Of course, the whole picture of a sun over the waters will not be complete without the common coconut and mango tree. Literally taken the word pacific the calmness of the ocean by wavelets instead of bigger waves. Not to be left behind are fence-like spiral cone of shell on both sides for a healthy marine life. And finally the snail-like spiral pattern to express a slow-pace of life similar to a very relax passing of time at the beach!

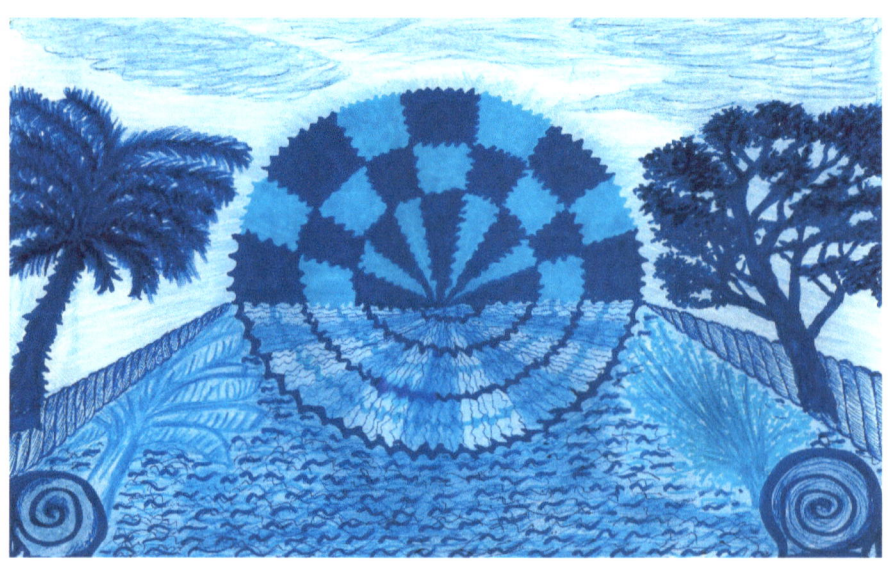

Flowers of Joy Series

Flowers of Joy

The characteristics of these three set of flowers is like the three orphaned sisters each named Mary. Mary the younger, Mary the middle and Mary the elder. Close to each other yet seems so far apart. They owned the 3-Sisters canteen in our district.

Mary the younger, though the youngest, it seems she is the only one smart enough when it comes to love. Or is too young to fall for it? Anyway, like yellow-orange buds of this flower in yellow innocence...still not fully open to love relationship. Until one day she has grown into a bright young woman in full yellow bloom.

Like the lively colour red of this flower (her utmost favourite colour), Mary the middle is the adventurous type, she is the life of every party. In spite of being free spirited and carefree, her most intimate yearning is to be only with someone as her soul mate to settle down and live a happy ending.

Last of the three, Mary the elder, her outward appearance of being classy, reserved and mysterious is only outside, like the colour lilac of this flower. Due to her selfless caring for her two younger siblings she looked aloof, un-approachable or snobbish but in reality she's very down to earth, caring, and very comfortable to be with.

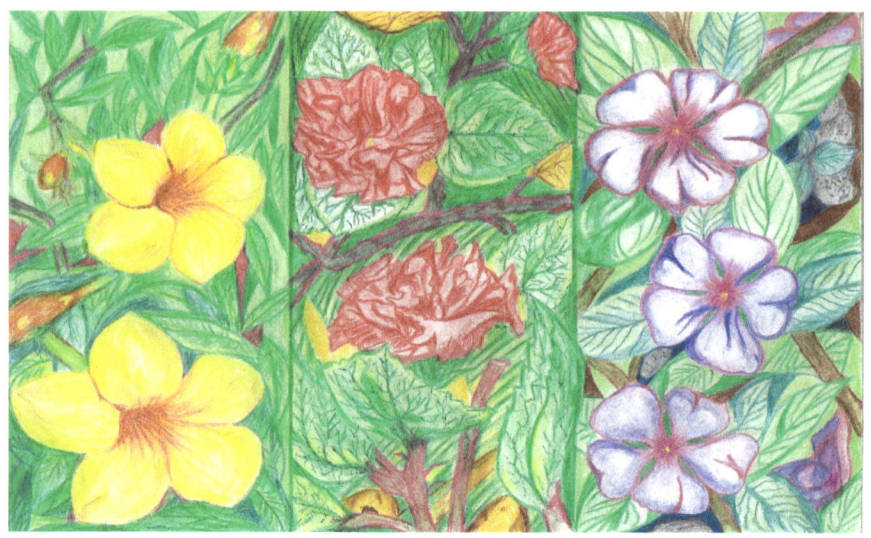

Flowers of Joy II

 An overall similarity of this drawing in my thoughts are the wildflowers. As the womenfolk who were unrecognized, unsung heroines who made vital contribution. Trying earnestly to survive in a fiercely competitive world. Like these wildflowers struggling to survive or thrive in a forest.
 Like the women-achievers in a concrete city jungle, they struggle hard like everyone else to be at the top of their game. Albeit some of them are really the 'femme fatales' and others with their wit, charm and elegance they are all worthy. They are not only the singletons, single moms, career ladies, techno-savvy girls, or common wives; they are also the grandmother, mother, auntie, niece, big sister, cousin and friend collectively rolled into one.
 As with the likeness of these wildflowers---combination of bright red symbolizes their vivacity and white for their purity of

heart for their personal goals. Those dark green with blackened bits of tiny patches as background represents bitter and tragic experiences they overcame. I say again, overcame, meaning they came out victorious, prevailed over the past. What is important is their full-bodied wholeness at the forefront leading with their very best!

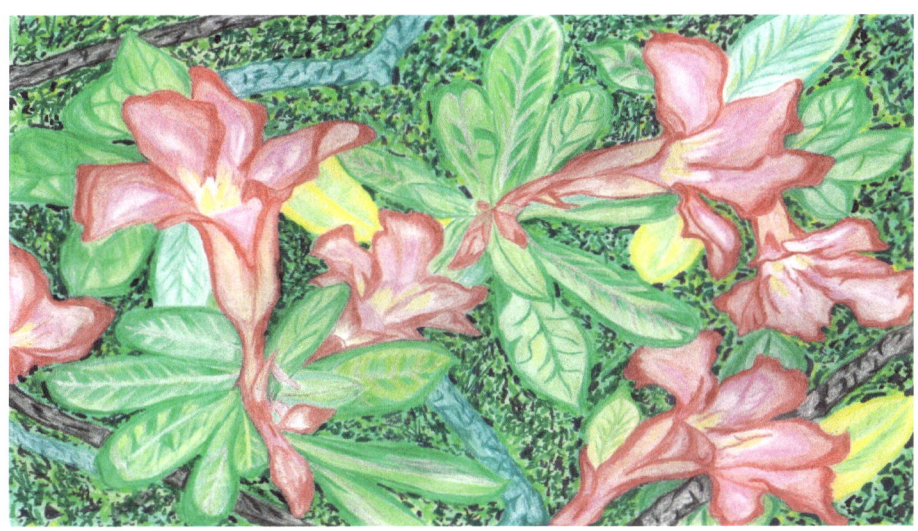

Flowers of Joy III

In this e-booklet as a whole, I started my first image of Wallflowers and now ending with Flowers of Joy III. But in between a variety of subjects, topics and messages of expressions.
As the very last image (of the e-booklet) and last of the series, I will not discuss similarities or symbolism but describe the five group of flowers as the representation of what is an ideal woman.

Sounds so simple to describe in five characteristics, but I will cite only the opinionated ones.

Starting from the centre, at the very core---the white flower is for the purity of a woman's conscience. Without this clear conscience...she must be true to herself first. Clockwise, from upper right corner; a woman with certain aura of subtle charm is a must for this dark lilac flower. Going down to the bottom right side...Without the red-hot interest in the opposite sex she is but an emotionless partner. Now, on the left bottom side, red-orange flowers is for her common knowledge in domestics that includes everything from cooking, washing to cleaning. And lastly, at the top left corner---the combination of pink, white and yellow for sure-fire creativity in a long lasting happy relationship.

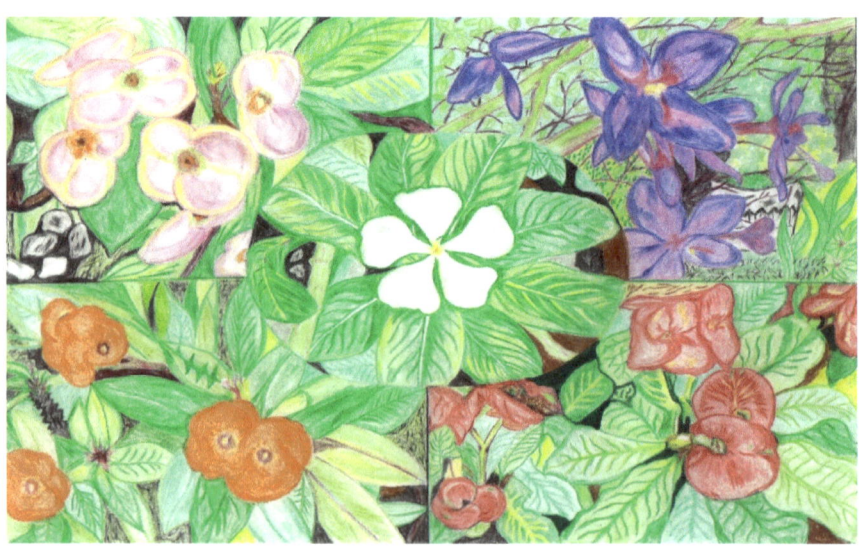

6 Epilogue

Finishing Touches

After finishing the last image for this e-booklet I still have the innate feeling of doodling around. But I controlled myself to the point that by psychologically putting my frame of mind. I thought of instantly converting this html file into a PDF but decided check each image to enhance readability. And simplifying the thought as much as possible without escaping to the point.

One of the retaining thought I had is that I need to have this manuscript copyrighted before I intend to finally e-publish as a booklet. So either way of whichever comes first---maybe I will complete this in html format, copyrighted and convert to pdf after touching up the finishes!

Enclosing the Borders

To summarize this whole idea of painting one's thought is enclosing a painting with borders. I was able to satisfy my desire to share my thoughts about my paintings and at the same time overcome the 'self-challenge' that I am able to create this for my future website!

Allow me to reiterate, that this e-booklet was written with absolute wish that it could help anyone to be creative in terms of painting. Improve the quality of "killing-time" by beating boredom through creative process. And conclusively--- my utmost wish that each one of us benefitted in sharing thoughts and humble artistic offerings.

7	Acknowledgements

Linear Gratitude

I cannot help myself grinning widely when I was contemplating on how to start writing the acknowledgements chapter of this e-booklet. The main reason is that instead of plainly writing on a regular manner (or somewhat conventional style), I found it is easier to do it in a "linear manner". Literally, underlining the names, give thanks (Salamat! Shukran! Gracias! Danken! Shishe!) and then presenting it in alphabetical order.

Thank you to the following: <u>Adrian H.</u> ---for showing his personal and company websites he developed earlier and for replying that his copy of Adobe Acrobat was left back in Philippines. <u>Gadget Lady</u>---for commenting that after chapter four she almost fell asleep, and thought of going back to her Mills & Boon paperback classics and Nora Roberts collections! <u>Joe B.</u> ---for his website free tutorials on Html. <u>Laura R.</u> ---for her comprehensive explanation on self-publishing. <u>Milo T.</u> ---for his basic tutorials and service to the Pinoy expats at United Arab Emirates. <u>Nesreen S.</u> ---for viewing the images and check how much time it will take to finish the whole manuscript. <u>Meong D.</u> ---for discreetly staring at laminated A4 copies of selected images, during "Thursday Club's" outing. And last but not the least <u>Rabab V.</u> ---for her email reply stating "seriously taking" my cake recipes than painting!

About: The inside cover icon & the author

The title of the inside cover icon is "Amelia's Pride Logo", it is the smaller version of the said image. While it has totally nothing to do with the rest of the images or entirety of the booklet text, it is the cover I intend to put on my experimental website. But then I decided to utilize it in this booklet accordingly for a very simplistic personal reason.

MO LEYVA aka Mohammed Leyva Saavedra is a freelance artist, songwriter-composer, ex-OFW, with a professional background experience in the import-export business, FMCG, structural-glazing, laminated glass and (lately) OCTG industry.

www.ingramcontent.com/pod-product-compliance
Lightning Source LLC
Chambersburg PA
CBHW040836180526
45159CB00001B/205